RUTHERFORD

Richard,
Thank you for your
interest and your work
on Rutherford history.
Enjoy the book!

2-09

WILLIAM NEUMANN

RUTHERFORD

A BRIEF HISTORY

Charleston H London

THE
History
PRESS

Published by The History Press
Charleston, SC 29403
www.historypress.net

All images are courtesy of the author unless oterwise noted.

First published 2008

Manufactured in the United States

ISBN 978.1.59629.539.1

Library of Congress Cataloging-in-Publication Data

Neumann, William.
Rutherford, New Jersey : a brief history / William Neumann.
p. cm.
Includes bibliographical references.
ISBN 978-1-59629-539-1
1. Rutherford (N.J.)--History. I. Title.
F144.R9N485 2008
974.9'21--dc22
 2008040209

CONTENTS

ACKNOWLEDGEMENTS

The Borough of Rutherford pushed me through the Drew University Historic Preservation Certification program, and for that I am forever indebted to my town. All the tireless public servants, committee volunteers and elected officials make Rutherford a truly mad laboratory for Historic Preservation. Rutherford is blessed to have their civic care.

I thank my neighbors, friends and historic preservation associates in Rutherford, Bergen County and around the world. Sharing personal histories with Mary Melfa, Bob Gorman, John Nieder, Ann Rodgers, Gene Hilt, Marietta Prato and the Cole, New, Platt and Armstrong families has been a joy. The Van Winkle family will forever be the story of Rutherford. Borough clerk Mary Kriston and borough historians Rod Leith, Virginia Marass and Lee F. Brown have always found the time. Historian Jim Hands continues to lead me down his living roads of wonder. Sadly, the lost warehouse of vast knowledge from the passing of Fred Bunker, Marjorie and Will Reenstra and Fred Patak cannot be replaced, but their inspiration lives on.

I have researched in many libraries throughout the world, but the Rutherford Public Library and its dedicated staff is the best of all. Our Meadowlands Museum holds countless treasures with professional respect afforded by Jackie Bunker Lorenz, Silvia Kleff and their volunteers.

I am indebted to the wizards at the Bergen County Historical Society and the County of Bergen's vast reserve of historic documentation. Carol Messer, Janet Strom and T. Robins Brown are unsurpassed historic preservation professionals. Barbara Marchant's dedication to our local history serves as a benchmark for all of us. I thank her for her thorough indexing.

Nancy Terhune is truly related to everyone. She is an outstanding genealogist, researcher, writer and a determined editor who kept this book on track. In my heart she will always be the tenacious Ms. T. I humbly thank her for her love and support.

My life has been forever filled with my family's wonderful stories and argumentative histories. The voices of my Aunt Roberta, Uncle Bill and Grandma Helen Adams

pushed the keys as much as I did. My sister Babette is not my twin, but thankfully we do share one mind. Finally, my mother, Babette, and my father, William, brought me here, taught me to walk and showed me how to gather in the magic that surrounded me in Rutherford. The gift of life is so precious, and I think of them every day.

I would like to invite you to see and share more of your histories of Rutherford, New Jersey. Please visit my website **www.RutherfordHistory.com** or contact me directly at **Bill@RutherfordHistory.com**

INTRODUCTION

As my father walked me down Union Avenue, he said that on certain summer nights, if you listened hard, you could still hear the ghostly steps of Native American spirits as they trod this "old Indian trail." He was a Congregationalist, so his acknowledgement of ancient spirits and their neighborly presence drew me like iron to a magnet. From that point on, my head filled with stories of Rutherford, and I would always listen hard for those steps.

Stories like these are sometimes just stories. But a history is different. Our country and culture began with a pinch of story, added a heaping portion of fact and mixed until our history is what it is today.

Rutherford's own history begins here as the story of a humble footpath that becomes a road, which one day leads to a historic railroad depot that welcomes people and their dreams into a new town. Dreams become realized in churches that become libraries, castles that become colleges and neighbors who build a town and change the world.

Rutherford is a beautiful town to walk through. There is nothing richer than experiencing history by seeing it up close and touching its surface. Throughout this book, I refer to many physical examples of "our" history. Some are gone, but many remain for your appreciation. I ask you to find and touch with your heart the historic places that Rutherford holds dear for you. Discover their stories, and then ask yourself whether, if you allowed "your" place to disappear tomorrow, you could still keep your mind open to the ghostly steps of the past.

Now, please take a walk with me through a beautiful history.

OF A LAND AND ITS FIRST PEOPLE

Rutherford's peninsular land, cradled by two rivers, provided sustenance for its first people and drew later ones to its bounty and advantageous location. When the Old World met the New, a cascade of events and nearly a dozen generations of a Rutherford family began.

Waling Jacobs looked to the river before him. His language was Dutch, but the Native Americans called this water *Piasiak*—thereafter "Passaic" to the European population. The river was a fearsome lifeline that both isolated and connected Waling to his family, his civilization and his God.

It was the dawn of the eighteenth century, and the land on which he stood had been his since the earliest time of European settlement in what is now Rutherford, New Jersey. This isolated area between the growing village of Acquackanonk, on the west bank of the river, and the "fresh meadows" to the east was a true frontier, and Waling was its first settler. He could not have known that his descendants, eleven generations of the Van Winkle family of Rutherford, would remain entwined with this land into the twenty-first century.

Waling faced west toward his river. To his left was a wide expanse of land owned by an Englishman named Nathaniel Kingsland. The Kingsland property stretched south along the river almost seven miles to the 1666 settlement of Milford, or New-Ark (today's Newark). To his right was a wider tract owned by John Berry, another Englishman. From this spot, Berry's property rolled north and inland from the river to the settlement of Hackensack. Trailing off behind Waling was the rough border between the two English land patents.

This border was a narrow Indian path that connected two bodies of water vital to the natives: the Passaic River and, to the east, Berry's Creek. From where he stood, Waling could turn away from the river and follow the trail as it rose up through dense forests, thick with deer and turkey, and past small ponds and streams. Just one and a half miles to the east, this narrow route bisected a collection of ever-bubbling springs. In the future, this important border would assume many names, including the "Old Indian Trail," Sandford Spring Road, Boiling Spring Lane and, finally, Union Avenue.

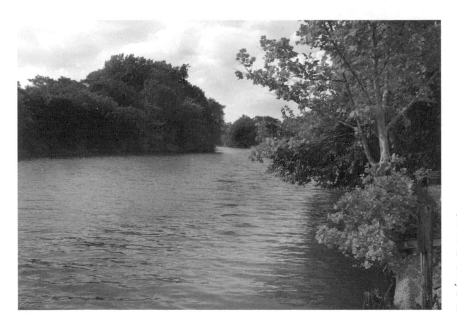

A view of the Passaic River from the approximate area of Waling Jacobs's original settlement.

Waling knew that by traveling past the springs and another mile east he would arrive at Berry's Creek, a meandering channel that fed into a wide river known as the Hackensack. Through the larger waterway, Waling could navigate a boat south and eventually land on the eastern shore of a large bay, the "Achter Kol" (later Newark Bay), and return to the civilization that he knew as the village of Bergen (today's Jersey City). Early on, Waling had realized that this convenient neck of land connecting the two rivers made his land very valuable.

When he returned from Bergen to his pioneer homestead, he could choose a different way. By sailing across the great bay and heading west and then north into the Achter Kol, he could hug the western shore close to the Puritan settlement of Milford and then continue up the Passaic to land on the shore of his property. The round-trip route to and from Bergen was approximately twenty-eight miles, with the Berry's Creek to Hackensack River leg shorter by three miles.

As he faced this riverway, Waling took comfort in knowing that across it, and less than a mile north, was the small settlement of Acquackanonk (now Passaic and parts of Paterson and Clifton). By fording the water at this somewhat narrow point near his land, he could walk north along its bank. When he arrived at the village, he could speak his language with people of his own culture and commune with his family and other settlers. He could trade, seek assistance and obtain valuable information to survive this wilderness. But, most important, this was a place to consecrate marriage, baptize babies and celebrate his God's salvation and abundance.

Today, we know he established his homestead at approximately the modern intersection of Hastings and Darwin Avenues in Rutherford. But how did Waling arrive at this location?

COASTAL WATERWAYS

Along the eastern coast of New Jersey, the lip of North America rises subtly out of the Atlantic Ocean. This geologic province is aptly named the Atlantic Plain. This costal plain flattens into the sea from the more mountainous inland highlands through a continuation of gradual downward plateaus and land terraces. Stretching far into the Atlantic and Gulf of Mexico, it becomes the submerged continental shelf. In some areas, the contrast between land and water is so indistinct that the boundary is often blurry and brackish. The Louisiana bayous, Florida everglades and the Hackensack meadows are wonderful examples of this subtlety.

From the perspective of a long ocean voyage, the Atlantic Plain appears shallow and welcoming. But it only offers safe portage for large ships at the opening of its great rivers. The entrance into New Jersey waterways, such as the Delaware Bay, Sandy Hook Channel, Raritan Bay and New York Harbor, must have appeared very inviting. But after traveling through the great bay that is New York Harbor and then up the Hudson River,, the Palisades rise up to fence in the mainland and deny easy passage by foot. The convenience of the inland river system enabled the real highways for exploration and, eventually, settlement.

EUROPEAN EXPLORATION AND NATIVE AMERICAN CONTACT

European exploration was almost always motivated by commercial gain. Overland trade routes to the rich lands of China were established as far back as 1271 by the Marco Polo clan of Venice. However, this trade route, and most others, became increasingly hazardous and unprofitable due to the collapse of the Mongol Empire. In the middle of the fifteenth century, it was reckoned that large seafaring vessels could travel unmolested

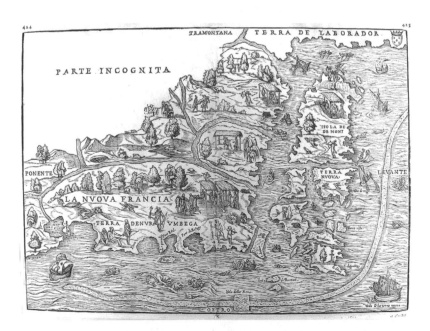

Giacomo Gastaldi, "The Northeast, 1556,"—the first printed map devoted to the New England region.

and might also return filled with more riches than what could be contained in bags on the backs of men and mules. With the invention of the printing press, distribution of navigation tables and ship plans (1450) and the wide acceptance of Ptolemy's geographic system, ocean exploration rose on the tides of great expectation.

Thus, in quick succession, an explosion occurred in all directions. Columbus embarked on his southwestern routes to India (1492), Vasco da Gama rounded the Cape of Good Hope and reached India (1497) and John Cabot sighted "new found land" while searching for the Northwest Passage to India (1497). Finally, in 1519, Magellan began a fantastic journey to circumnavigate the world with five ships and 270 men.

Voyages begun in the ports of Italy, Spain, Portugal, the Netherlands, England and France were financed by royalty, who demanded their ships return loaded with valuable spices from East India. At the very least, mariners were required to produce maps of quicker routes and land claims that, in turn, could be exploited for future treasure. During the sixteenth century, Englishman Sir Francis Drake and French explorers Jacques Cartier and Samuel de Champlain would peck at the coast of North America in search of a simple waterway through it to the riches waiting on the other side. A typical voyage was made by a Florentine sailor, who was backed by King Francis I of France and Italian bankers. Giovanni da Verrazzano set sail with four ships from Madeira on January 17, 1524. Only his flagship, *La Dauphine*, endured the journey across the Atlantic. In March, *La Dauphine* anchored just inside New York Harbor. His crew was the first to encounter the Native Americans of this region. Since it was determined that the fresh waterway before him could not be a passageway to the Pacific, Verrazzano drew up anchor and continued to explore the northern Atlantic coast.

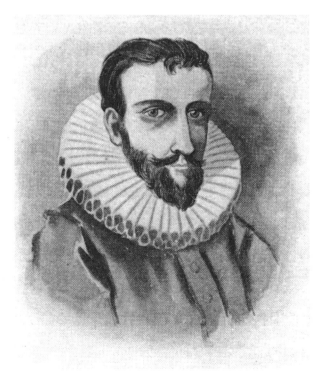

Henry Hudson.

In April 1609, the English captain Henry Hudson departed Amsterdam in a flat-bottomed ship not quite sixty feet long. Named *de Halve Maen*—"*the Half Moon*"—it had a crew of eighteen Dutchmen and Englishmen, and it made its voyage on behalf of the Dutch East India Company. Hudson's Atlantic crossing deposited him close to present-day Sandy Hook, New Jersey. During September, he became intrigued by the vast waterway that would become the entrance to the New York and northern New Jersey harbor. Eighty-five years after Verrazzano, this captain anchored and considered his options. On September 10, he decided to sail up this somewhat freshwater river. As with Verrazzano, Hudson's voyage up the North River (Hudson) afforded him close contact and trade with the Native Americans later to be known as the Manhattans. But, more important to Hudson, he believed that this exploration entitled him to claim this vast empire for the Dutch.

It is now supposed that the ancestors of the Native Americans Hudson encountered may have crossed the Alaskan land bridge joining North America with northern Asia and eastern Russia. These first Americans may have been nomadic Mongolian people who followed an eastern flow of game into a new world. Then, seeking warmer, more productive climates, they scattered southward down through Canada and the Great Lakes, with many cultures communing along the Atlantic coast and its abundant waterways.

The native people in our region are now known as the Lenapehoking. This term was derived by the original European translations of Lenape (Len-NAH-pay) and sometimes Renapi (Ren-NAH-pe). They were part of the large group of Algonquian-speaking peoples who spread throughout New Jersey and Delaware. The Lenape were locally organized but did use a network of paths and trails, which the location of many of our present roadways mimics. These people were loosely grouped into three geographic areas and known as the the Unami (Turtle), or the people "down the river in the central portion"; the Unilachitgo (Turkey), or the people who are next to "the ocean in the south" (the Delaware); and the Minsi (Wolf), or the people of "the stony country in the north." However, it is incorrect to think of these groups as being spiritually tied to these animals as totems. It is estimated that the Lenape population may have ranged from eight thousand to thirteen thousand near the time of European contact.

The Minsi Lenapes inhabited our area and made use of the fertile hunting and fishing grounds. Primarily hunter-gatherers, they cultivated beans, squash and corn. They trapped birds and small animals that ranged up to the size of deer. Evidence of their fishing methods can still be seen in the Passaic River fish weirs, or *slooterdams*, near Fair Lawn and the petroglyphs on river rocks in Garfield. Native settlements have been discovered within Newark and near Nutley at the Second River. The Minsi termed the peninsular area between the Hackensack and Passaic Rivers the *Meghgectecock* (possibly derived from an Algonquian term, *masgichteu-cunk*), or "where the May Apples grow."

Obviously, the voyage of the *Half Moon* did not produce a water route through the North American continent. Hudson's return to Amsterdam was first deemed a failure by the Dutch East India Company, but he did return with interesting tales of the natives. He was also able to produce rough maps outlining the area occupied by the Manatthan natives so as to intrigue many Amsterdam merchants. From 1611 to 1614, eleven ships retraced Hudson's route back to the Mid-Atlantic to explore and trade with the

natives. On one voyage in June 1613, Captain Thijs Mossel left behind crewmember Jan Rodriguez, a San Domingo mulatto, to further traffic with the Manatthans. Sadly, only a slight history exists to tell the brave story of this first settler among the Manatthans. The empire claimed by the Dutch was called New Netherland. It would be another six years before the pilgrims would land at Plymouth Rock.

THE DUTCH ARRIVE

It is uncertain who was the first European to sail up the Passaic and Hackensack Rivers. Historian Frances Loehler has suggested that, in 1613, two Dutch captains, Henrick Christiaensen and Adriaen Block, may have made the first true explorations. By 1616, a map produced by Cornelius Hendricks somewhat proscribes present-day New York Harbor and Newark Bay. But the trade in beaver pelts and other goods became important enough for the Dutch to form the West India Company and establish a colony amidst the Manatthans. In the summer of 1624, the ship *Nieu Nederland* put ashore eighteen settlers on *Noten Eylant* (now Governor's Island). In little more than a year, two hundred farmers, merchants and hired workers populated the surrounding islands. They were supplied with three hundred head of livestock, including horses, cows, hogs and sheep.

Although the European principle of land ownership was not truly appreciated by the Lenape people, Dutch (and later English) policy required a formal purchase from the Indians of any land to be settled upon. It was actually Canarsee natives who made the much-storied sale of an island for "the equivilant of 24 dollars in trinkets." But the

The *Nieu Nederland* ship.

Canarsee only occupied the bottom half of the Manatthans' island and mostly near the Collect Pond (now Beaver Street). They may have thought this offering absurd or confusing, but they took it. It is also doubtful that the colony's newly installed director, General Peter Minuit, was on hand to dispense the payment. The November 5, 1626 New Netherland progress report to Amsterdam does not mention Minuit, but it does detail the twenty-two thousand acres "purchased," along with samples of excellent grain gleaned from it.

To further the expansion of New Netherland in 1630, the Dutch West India Company offered new incentives, called "Privileges and Exemptions for Patroons, Masters and Private Individuals who Settle in New Amsterdam." A patroon was a charter member of the colony who was entitled to his choice of unoccupied lands to establish company farms, or "Boueries." Most of the "unoccupied lands" were across the river on the mainland. So it was that the first documented land purchase in northern New Jersey was made on July 12, 1630, when Patroon Michael Pauw obtained present-day Staten Island and Hoboken from the sachems (chiefs or leaders) Armmeauw and Sackwomeck. For the next thirty years, the enterprising Dutch attempted to establish their farms in the areas of Pavonia, Communipaw, Harsimus, Paulus Hook and, finally, Bergen.

Throughout the settlement of New Netherland, tension between the Europeans and the Native Americans became hostile. On the island of New Amsterdam, a walled area was erected along the same line as today's Wall Street, and Fort Amsterdam was constructed just south of Bowling Green. During much of that time, open warfare existed. This was particularly frequent on the west side of the river, as settlers had very little protection. By 1645, the entire New Netherland colony was in shambles, and in 1654 the Dutch West

Detail of Vanderdoncks's 1650 map showing New York and New Jersey waterways.

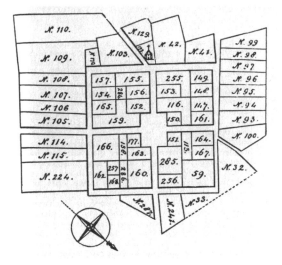

Winfield's map of Bergen, 1664.

India Company was effectively bankrupt. Still, New Amsterdam had grown to more than six hundred souls determined to fortify it.

A lasting peace was established with the Native Americans, and expansion spilled over to the west bank. On August 16, 1660, a plan was approved to set out farms to surround the new and permanent village of Bergen. A stockade square was constructed roughly proscribing today's Bergen Square, bordered by present-day Tuers, Newkirk, Van Reypen and Vroom Streets. The nascent village would firmly establish many of Rutherford's most prominent and adventuresome families. Names that are familiar today, such as Kip, Van Winkle, Van Reyper, Yereance and Vreeland, were engendered within the Bergen village. Once settled, this small, secured community became the launching point for exploration into the immediate mainland of North America. Truly, the settlers of Bergen were the first in a long line of Bergen (later Hudson) County immigrants who eventually moved west in search of better lives.

REQUIEM FOR THE FIRST PEOPLE

From 1664 forward, original land transactions in the Rutherford area involved newly imposed English land laws and how those laws were misapplied to the often misunderstood Native Americans. Eventually, with the Treaty of Easton in 1758, Native Americans in New Jersey had mostly relinquished their remaining lands. Sadly, without land left to sell, the Lenapes were forced to emigrate west to settle temporarily in Pennsylvania, Ohio, Indiana, Missouri, Kansas, Arkansas and Texas. Many finally arrived as far west as Oklahoma. Diseases imported by Europeans, such as smallpox, typhoid and tuberculosis, decimated Native Americans. It is estimated that fewer than three thousand Lenapes actually survived war, sickness and the final removal from their ancestral lands. By the end of the French and Indian War (1754–63), the Native American population in New Jersey was under one thousand.

OF KINSHIP, A COLONY AND COUNTIES ESTABLISHED

Even as the lives of the New Netherland Dutch were turned upside down by the new rule of the English, life seemed good and promising. English land grants spurred settlement on both shores of the Passaic River, and the speculations of Englishmen from the island of Barbados brought Rutherford's first European habitants. But how did Waling Jacobs identify himself and his frontier land?

Waling Jacobs was born in 1647 or '48, the first son of Jacob Walings and Tryntje Jacobs. He was married March 15, 1671, to Catharina Michielse, daughter of Michiel Tades, at the village of Bergen. As Waling's family moved off the locus of New Amsterdam, they acquired many parcels of property: first in the Bergen village area, but eventually westward to the banks of the Passaic River. Some of the land they sold for profit, and some they occupied. Some of these places would eventually be identified with their original family names, such as present-day Wallington, New Jersey.

Waling Jacobs's early family was Calvinist and Dutch Reformed in faith. Although their money was once counted in Dutch guilders, now, with the imposition of English land rule, their wealth was legally measured in English pounds. Waling Jacobs needed to commingle and barter with the English and the Indians, but he spoke mainly Dutch. He would have referred to native place names and might have attempted to understand the Algonquian language.

From Waling Jacobs's riverside vantage point in Rutherford, he knew that the closest meeting place for his people was across the river at Acquackanonk. The Acquackanonk Patent had been obtained by Waling, and thirteen of his fellow "Bergenites," who sought to invest in land west of the village of Bergen. It was deeded to Christopher Hoagland and then to Hartman Michielse. As was the law, the transaction was consecrated and released by the Indian sachem Captahem on March 28, 1679. The patentees acquired more land from the East Jersey Proprietors to total almost ten thousand acres extending from the Great Falls south to the Third River. The tract was fully granted by the English in 1684, with the fourteen patentees to occupy the west bank of the Passaic. Among the

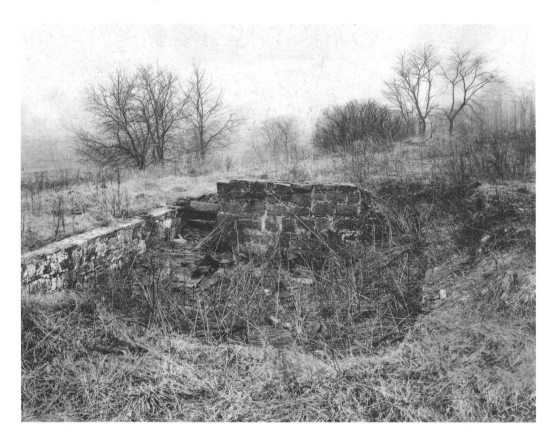

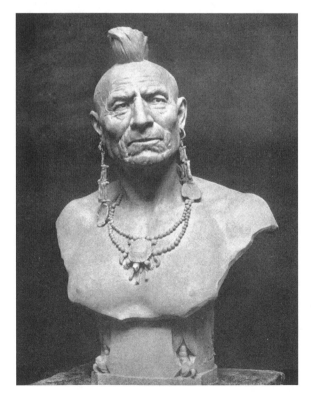

Above: The 1926 remains of Waling Jacobs's original homestead on the Passaic River. *Courtesy of the Bergen County Historical Society.*

Left: A sculpture of Native American Sachem Oratam, by John Ettl. *Courtesy of the Bergen County Historical Society.*

original settlers were Waling and his younger brother, Symon Jacobs. "The Fourteen" set out farms of approximately one hundred acres each that were situated all along the riverbank. The area was soon called Acquackanonk Landing, and it became the most important local river port.

Almost immediately after the land was apportioned, the Dutch Reformed Church of Acquackanonk was organized, though it would be some time before the church structure was built.

Downriver from Waling's land, the Newark settlement continued to prosper and expand toward Second River (Belleville and Nutley). To Waling, this may have seemed to be another English encroachment on the southern border of Acquackanonk. Many of the original settlers were foreign to him, some having arrived from New England, Long Island and Scotland. Waling was in fact governed by, obliged to and would soon be legally renamed by English law.

Waling was also connected to the Dutch settlement of Hackensack. The Indian sachem Oratam deeded the land that encompasses present-day Hackensack to the Dutch in 1665. From his original land patent, Captain John Berry set aside two and three-quarters acres for the Dutch Reformed Church of Ackensack. The original church, like most early Dutch churches, was a simple octagonal stone and wood structure. But once this edifice was erected, it solidified the community.

THE ENGLISH TAKE CONTROL

Just as the Dutch were seeking to expand their colonization, another nation took full notice. In March 1664, English King Charles II dispatched an expedition of three warships with six hundred men to enforce his right to possess the entire Dutch province of New Netherland. King Charles held that the 1498 North American discoveries made by Sebastian Cabot had set this area squarely within English rule. When his armada sailed into the bay at New Amsterdam, the Dutch population decided it would be prudent not to attempt a fight with the heavily armed British. As the Dutch colonists reluctantly accepted their new lords, they remained uniquely Dutch and only adapted portions of English culture that proved useful. By 1665, the English had renamed the colony of New Amsterdam "New York" for James II, Duke of York, brother of Charles II. This was the start of the enforcement of their sovereign territory on the Atlantic coast. This large section of North America not only included our present locality but also ranged from New England all the way to Georgia.

During the English civil wars, the Isle of Jersey proclaimed loyalty to the royal House of Stuart and gave sanctuary to King Charles. It was there that Charles II was first proclaimed king in 1649. Following the reestablishment of the Crown in 1661, attention to royal possessions in North America was renewed. To further empower his royal colonization, Charles II gave his brother James the entire region between New England and Maryland as a proprietary colony. It was on June 24, 1664, that the Duke granted the land between the Hudson River and the Delaware River to Loyalists Sir George Carteret of Jersey, Channel Islands, England, and Lord Berkeley of Stratton. Carteret

and Berkeley became, by royal patent, the Lords Proprietors of the lands that were "hereafter to be called by the name or names of Nova Caesarea or New Jersey."

The two proprietors sought to bring more settlers to the area by giving grants of land paid for in annual fees called quitrents. They passed the 1665 Concession and Agreement, granting religious freedom to all inhabitants of New Jersey. It was somewhat revolutionary, as the Church of England allowed for no such religious deviation. From 1664 to 1702, the land now known as New Jersey was governed as two distinct areas called West Jersey and East Jersey. The two provinces were then united under one royal governor on April 15, 1702, as a single royal province named New Jersey.

COLONY AND COUNTIES

The village of Hackensack was situated on the Hackensack River and prospered as many Dutch and English farmers acquired surrounding land. But the village was still a part of Essex County until 1710, when Bergen County was enlarged and the township of New Barbadoes was removed from Essex County and added to Bergen County. At that point, Hackensack was recognized as a more centrally located settlement to which the majority of Bergen County's inhabitants could travel. Much of the governing power and early courts were located within its borders, and it was eventually chosen as the county seat.

By the turn of the eighteenth century, New Jersey was the common name for this English proprietary colony. In 1675, four provisional areas—Bergen, Essex, Monmouth and Middlesex—had been empowered as judicial districts. Then, on March 7, 1683, Bergen and the other three were recognized as independent counties.

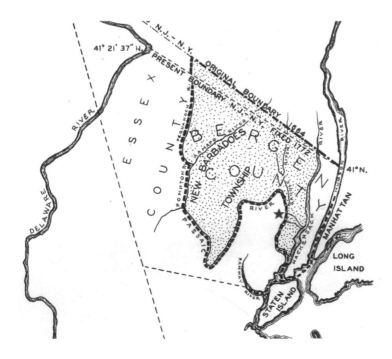

A WPA map of Bergen County, 1710. (The star indicates the Rutherford area.)

At the time of its creation, Bergen County also encompassed parts of today's Passaic County and Hudson County. The peninsula between the Hackensack and Passaic Rivers (which contained Rutherford) was now most commonly called New Barbadoes Neck. It was also part of the original Essex County from 1682 to 1709. With the January 21, 1710 realignment of county boundaries, the Rutherford area was then contained in the newly expanded county of Bergen.

Two Englishmen from Barbados

In many ways, Rutherford's history starts with the years 1668 and 1669. The time was just four years after the English had wrenched control from the Dutch, and English settlers were flooding into the region. Attempting to stimulate settlements on their vast unoccupied "frontier" lands, the Lords Proprietors of East and West Jersey granted expansive patents. Several Barbadian Englishmen obtained patents for large swaths of land between the Hackensack and Passaic Rivers, knowing that the Dutch of Bergen were interested in (and financially prepared for) westward expansion.

The first patent, dated July 4, 1668, was issued jointly by Lord Berkeley and Sir George Carteret to Captain William Sandford. It stipulated that he would establish six or eight farms within three years and pay twenty pounds sterling on the twenty-fifth day of every March. In a confirming deed dated July 20, 1668, Sandford purchased from the Indian sachems Hanyaham, Gosque, Kenorenawack, Anaren, Tamack and Tantaqua a tract of land

> to commence at the Hackensack and Pissawack Rivers and to go northward about seven miles to Sandford's Spring. Consideration, 170 fathoms of black wampum, 200 fathoms of white wampum, 19 black coats, 16 guns, 60 double hand of powder, 10 pair breeches, 60 knives, 67 bars of lead, one anker of brandy, 3½ vats beer, 11 blankets, 30 axes, 20 hoes and 2 cooks of dozens.

The transaction was conducted in the interest of Major Nathaniel Kingsland, who financed the undertaking while residing at the parish of Christ Church on the island

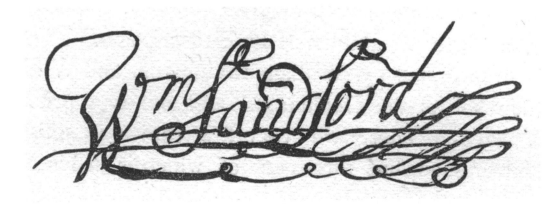

The signature of William Sandford.

of Barbados. This vast purchase encompassed 5,308 acres of upland and 10,000 acres of meadow. It stretched from river to river and began just above the Milford (Newark) settlement all the way north to Sandford Springs, or present-day Rutherford. The captain named this area "New Barbadoes Neck."

In June 1671, Major Kingsland and his wife, Mary, sold one-third of their estate to Captain Sandford. Kingsland retained the northern majority of this grant, including present-day Rutherford, while Sandford received the southerly portion closer to Newark. Sandford resided for a time in the Newark settlement. This sale was confirmed in May 1673, and by the next year Sandford began to establish his plantation on the east bank of the Passaic.

Although Nathaniel Kingsland never came to this country, he was able to sell his Rutherford property in two transactions. He first disposed to Bartholomew Feurt the area between the "Old Indian Trail" border to present-day Highland Cross. In 1707, Feurt resold to Waling Jacobs a western parcel extending to the Passaic. The eastern part went to John and William Stagg from Bergen. John was a stonemason and one of the builders of the original 1696 Dutch Reformed Church of Hackensack. Eventually, a remainder of the land was disposed to Elias Boudinot, who sold this property to Jan Jurianse (later "Yereance," a branch of the Van Reyper family) on February 1, 1724. The second parcel of Kingsland's was bequeathed to his two sons, John and Nathaniel, and to his nephew, Isaac.

Captain Sandford became the presiding judge in the first courts of Bergen County in 1676 and a member of the first Council of East Jersey in 1682. He died in 1692 and was buried on his own plantation.

The second important land grant was obtained by Captain John Berry. As with Sandford, Captain Berry arrived in New Netherland from Barbados. Berry first resided within the village of Bergen and used Samuel Edsall as a business partner to acquire property in Pennsylvania and New Amsterdam. He sought for his own possession the lands adjoining Sandford's that extended north toward Hackensack. On June 10, 1669, Governor Carteret granted and described the parcel as "land toward the head of Pesawack Neck, now called New Barbadoes, from Sandford's Spring six miles up into

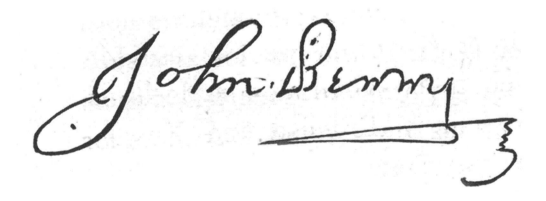

The signature of John Berry.

the country" and between the two rivers. This was later confirmed in the Indian Deed of February 28, 1672, as "all the land adjoining Capt. Sandford up the Pasagack River, five rods beyond the Warepeake Run, thence, across to Hackensack R."

Rutherford historian Margaret Riggs, in her 1898 book *Things Old and New from Rutherford*, provided the following description by historian Henry Copeland:

> *John Berry sold the western part of his property lying in Rutherford and East Rutherford on March 26, 1687, to Waling Jacobs and the eastern part to Garret Van Vorst and Margaret Stagg. This division line began at Union Avenue, at a point about 100 feet east of Riverside Avenue, and extended to the Paterson Plank Road…The Stagg property passed in 1742 into the possession of the Vreeland family. The Van Vorst tract was divided by Garret Van Vorst between his two sons, Walling and Cornelius, Walling taking the part adjoining Union Avenue and Cornelius the northeasterly part. Cornelius sold his share to R.J. Van Horn, who sold to J.S. Banta, and he in turn conveyed to Isaac Ackerman, in which family it remained a long time.*

The area proscribed by these two original land claims was vast, as it extended from Newark north past Hackensack. However, it is important to remember that the division line between these two great land patents was always construed to be the Old Indian Trail—now Union Avenue—from the Passaic River to Berry's Creek. By today's measure this crude pathway made a poor border. But because it was the only man-made line and was recognized by the Native Americans, it seemed to be the only logical demarcation.

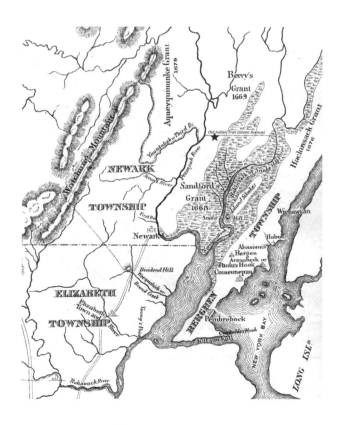

A map of the Berry and Sandford patents. (The star indicates the Rutherford area.)

In addition to being one of the wealthiest landowners, John Berry was extremely active in the early government. He was a member of the Governor's Council of East New Jersey for nearly seventeen years, president of the Bergen County Court of Judicature, justice of the Court of Common Rights, major for Bergen County and chief ranger for Bergen County (1683).

The wealthy Captain Berry may have maintained more than one residence on his expansive land. Some historians believe that one residence was the old Kip Farmhouse that stood on Union Avenue in Rutherford until the 1920s. He gave lands for various purposes and donated the land for the Dutch Church of Hackensack in 1696. A memorial stone with his initials was removed from the original structure and is located on the east wall of the present church. He died in New York. The will of John Berry was dated May 16, 1712.

IMPOSITION OF ENGLISH ORDER

Throughout the royal imposition of the new English order, important changes would occur. Although the Dutch guilder or florin would remain in circulation for a brief time, the English established the pound sterling as the coin of the realm. They also insisted on better property and other civil records and required the Dutch to adopt surnames for finer identification and record keeping.

Originally, the close-knit and practical Dutch rarely bore surnames, needing to distinguish individuals of the same first name only by their parentage. Like many European cultures, they used a patronymic naming system wherein one's given name was followed by a form of his or her father's name. To use a familiar example, the name of Waling Jacobs (also Jacobse) meant "Waling, son of Jacob." Waling's son Jacob, from whom Rutherford's present-day Van Winkle family is descended, was called Jacob Walingse, or "Jacob, son of Waling." At the point, in the late seventeenth century, when English civil record keeping required the Dutch to adopt surnames, the family took the name "van Winkle"—"from Winkle," a town in northern Holland where they may have originated. Other Dutch families were adapting old-country place names. Some were adapting patronymics into surnames, Rutherford's Yereance family being a good example—Jurie "Jurianse" anglicized his name to Jeremiah "Yereance." Some took on a variation on the name of their Dutch hometown, Reypen.

And so to return to Rutherford's first Dutch settler, Waling Jacobs Van Winkle, as he contemplated his river.

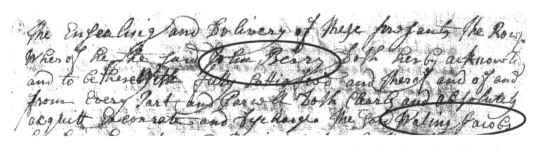

A section from the 1687 deed by John Berry to Waling Jacobs. *Courtesy of Office of the County Clerk of Bergen County.*

OF LIBERTY, FREEDOM, INDUSTRY AND IDENTITY

It was a tense and treacherous time, and all of Bergen County was captive to the strife of the War for Independence. As a new nation came together, Rutherford began the search for its own identity.

Waling's extended family expanded mightily on both sides of the Passaic River. Waling and his brother Symon (another of the fourteen Acquackanonk patentees), just two of the six children of their immigrant father, Jacob Walings, had twenty-one children between them and grandchildren totaling an uncounted number projected to be over one hundred. Symon had remained in Acquackanonk after Waling's departure, and so had some of Waling's children.

Waling's three sons inherited his lands in and around present-day Rutherford, though few of their descendants remained. Among those steadfast descendants were children of his sons Jacob and Johannis. It was Jacob's descendants who count among them today's Van Winkles of Rutherford. Johannis's son Waling ascended to the office of justice of the peace for Bergen County and became a commissioned officer in the New Jersey Militia. He was not the only Van Winkle descendant to serve in the Revolutionary War. The Van Winkles were well represented among the Patriot fighters, including twelve New Jersey Van Winkles of the thirteen recognized by the Daughters of the American Revolution (DAR).

THE SCHUYLERS AND THEIR MINE

One of the most prominent families in our area was the Schuyler family. Arent Schuyler was born in Albany, New York, on June 25, 1662, and he became the first of his line of Schuylers to settle in New Jersey. Although very Dutch in culture, he was a strong defender of the English Crown and its government in the colonies. He profited greatly by speculation in land all over the region and soon had land in the Essex, Passaic, Morris, Hudson and Bergen County areas.

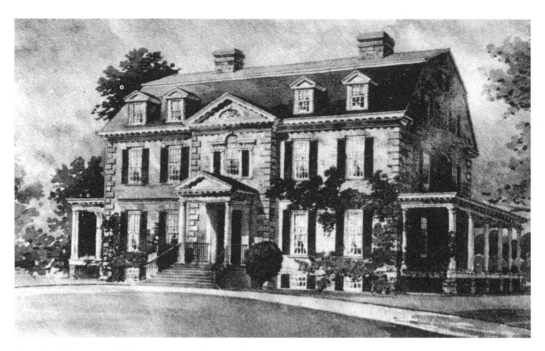

Schuyler Mansion, 1710—the home of Arent Schuyler.

Arent Schuyler purchased a tract of land from the Kingslands that was within New Barbadoes Neck. He bought this property in 1710 for £300 and constructed a lavish home overlooking the Passaic River. The magnificent Schuyler Mansion stood in the vicinity of today's Bennet Avenue. The grounds around the mansion were expansive and well cultivated for food and luxury. But all this was not maintained by just the Schuyler family. Arent was one of the largest slaveholders and slave traders in northern New Jersey.

As Graham Hodges documents in his book *Root & Branch: African Americans in New York and New Jersey*, slavery was widespread throughout eastern New Jersey, but it seemed to have been most prevalent in the Bergen County area. A 1726 census of New Jersey showed 18,062 people throughout the colony with 1,500 (6.7 percent) of them African Americans. Of Bergen's total population of 2,673 souls, 2,181 (81.6 percent) were white and 492 (18.4 percent) were black. Twelve years later, Bergen's black percentage rose to 806, or 19.7 percent. This percentage remained near 20 percent throughout the eighteenth century. There were very few "free blacks," as noted in the Bergen census of 1790, which showed 10,108 whites, 2,302 slaves and only 192 free black people. There seems to be no official counting of Native Americans by the English. The very first New Jersey census figures reflect the growth of the area but also the lack of substantial settlements.

On his manor and plantation, Captain Schuyler and his family would "employ" nearly two hundred slaves at various times. As the story goes, in 1719 one of Schuyler's older slaves came across a large green rock. He brought it to the attention of Arent Schuyler, who guessed what it might be and sent it to England for analysis. It was assessed to be 80 percent copper.

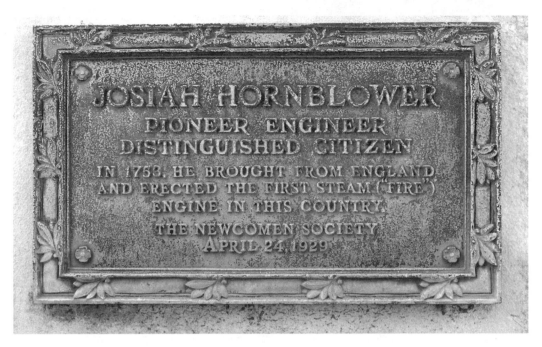

The grave marker of Josiah Hornblower at Second River Church, Belleville, New Jersey.

In 1720, mining operations commenced, but they were limited to very basic strip mining. Raw ore was loaded onto carts and taken to a water source for cleaning. Once cleaned of debris, it was loaded aboard ship at a dock on the Passaic River. By royal decree, copper, as all other metals, could not be smelted in the English colonies, so by 1725 Arent Schuyler contracted John Walters to ship all his ore to British ports. It is recorded that the Schuyler Mines shipped 1,286 tons to the Bristol Copper and Brass Works in England.

Arent was also actively at work in civic matters. When he first settled on New Barbadoes Neck, the closest church was a rough structure called the Dutch Reformed Church of Second River, organized in 1697. In 1724, Arent gave the church a large parcel of land and had a new stone house of worship erected. This church, though remodeled several times, is still in existence. His family also cut some of the first roads through the area. The Belleville Turnpike was originally extended from the Schuyler Mines to the Passaic River and opposite the Dutch Church about 1759.

After his father's death in January 1730, Arent Schuyler's third son, John (1697–1775), inherited the family mines and become the second lord of Schuyler Mansion. But his trade was not as simple as his father's. Now, deep shafts had to be burrowed into the earth to find profitable veins of ore. It was more costly to bring the ore from such a depth as the mines were constantly filling with water. John Schuyler learned that in the mines of Cornwall, England, Josiah Hornblower was installing steam-powered pumps for the ironmonger Thomas Newcomen. In 1753, Schuyler persuaded Hornblower to travel to New Barbadoes Neck to create the first steam engine in America. This "fire engine" was a popular curiosity that drew the attention of the likes of Benjamin Franklin. It worked

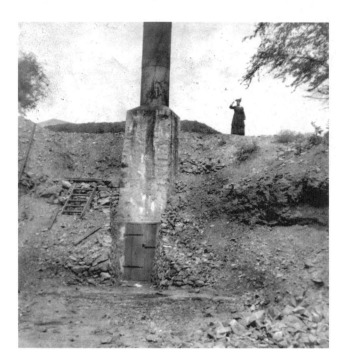

The remains of Schuyler Mines, the site of the first steam engine in the United States.

to pump out the waterlogged mine shafts, but it was not as productive as expected. However, Josiah Hornblower adapted fully to his new home. As New Jersey established a revolutionary government, Essex County sent Hornblower to the New Jersey State Assembly. During the War of Independence, Josiah Hornblower became a bold Patriot and an admirable proponent of freedom. In 1781, he narrowly escaped capture by a band of New York Tories foraging in New Barbadoes Neck.

Over a quarrel of religious dissent in 1752, John Schuyler broke from the Dutch Church of Second River (William Street in Belleville) and joined the nearby Episcopal Christ Church of Second River (Rutgers Street, Belleville). With his brother Pieter, he was instrumental in establishing this young church and the surrounding town. The graveyard of the church eventually held as many as sixty-six Revolutionary War Patriots. Much of the Schuyler family, as well as Josiah Hornblower and some of his family, are interred there.

THE WAR FOR INDEPENDENCE

It is a curious circumstance that so many people still do not realize that New Jersey can truly be called the "Crossroads of the American Revolution." New Jersey was wedged between the two largest and most important cities in the colonies, New York and Philadelphia. It had a huge, indefensible coastline situated square in the middle of all the other colonies. During the war, General Washington and the Continental army spent more time in New Jersey than any other area. No state suffered through more military action, property devastation and civil conflict than New Jersey. The crucial battles of

General George Washington.

Princeton, Monmouth, Red Bank and Springfield, and the recapture of Trenton with Washington's triumphant Christmas crossing back across the Delaware, all testify to how importantly New Jersey contributed to the freedom of our country. Although no major battles were fought within the confines of New Barbadoes Neck, the area paid a dear price for its liberation. Constant foraging by all occupiers, Loyalist families fighting Patriot families, terrorism, hostage-taking, murder and eight years of economic repression broke the spirit and tested the wills of many local colonists.

On July 12, 1776, British Admiral Richard Howe sailed aggressively into New York Bay. George Washington assumed an offensive position, but the battles of Long Island and White Plains, and the evacuation of Brooklyn Heights, began a tactical retreat for the general and his army. On September 21, Paulus Hook (Jersey City) was evacuated and became the first New Jersey territory occupied by the British. The nation's most important city, New York, was rapidly occupied and fortified as an English stronghold.

THE FATE OF A BRIDGE AND AMERICA

During the autumn of 1776, General Washington and his army were constantly pressed north and were forced to cross the Hudson River at Stony Point into New York and move south. They arrived at Fort Lee on November 13. On the New York side, the British captured Fort Washington. Fort Lee in New Jersey was now compromised for defending the North River (Hudson) pass. General Nathanael Greene abandoned the fort and began a hurried retreat to Hackensack just as British General Lord Cornwallis landed at Closter Dock. Washington's army crossed the Hackensack River at New Bridge

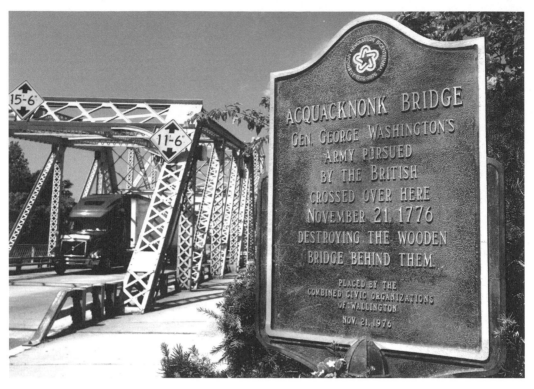

The modern Acquackanonk Bridge and sign, part of Washington Retreat Route, 1776.

Landing and passed through Hackensack, hoping to soon cross over the Passaic and not be hemmed in on the peninsula that is New Barbadoes.

On November 21, Washington quickly moved his army and its stores across the bridge as the Patriot citizens of Acquackanonk, and then Second River (Belleville), welcomed the general and his men and helped to guide them toward Newark to establish a temporary headquarters. Despite modern claims, this seems to be the nearest General Washington ever came to the Rutherford area.

To further delay British pursuit, Washington ordered that the bridge be cut down and destroyed. This surely was a crushing blow to the communities connected on both sides of the span, as it was the most important crossing from the Neck to the mainland. It would be rebuilt in 1779, but again destroyed, this time by ice during the winter of 1781. Seven years elapsed after the end of the war in 1783 before the Passaic was again bridged at Newark.

In many ways, the isolation of the New Barbadoes peninsula helped the scattered Dutch farmers avoid large-scale warfare on their soil. It is probable that much of the history regarding local involvement was not fully noted. The area encompassing present-day Rutherford was lightly populated farmland and contained no civil or religious centers to record immediate facts. The Neck was somewhat neutral, but tragedy and deprivation were constant as each side demanded food, firewood and sworn loyalty from anyone encountered.

Typically, British troops massed by the hundreds and scoured New Barbadoes farms for livestock, produce and wood, extracting whatever they needed from Patriot and Loyalist alike. In September 1777, Sir Henry Clinton sent a two-thousand-man foraging expedition into Bergen County and removed four hundred cattle, four hundred sheep and a number of horses.

To the east, the British held much of the land in proximity to New York City. Present-day Snake Hill (Secaucus) was part of a 1653 Sikakes Native American deed for the land on the west side of the Hudson River. During the rebellion, the rocky point served as lookout and encampment site for British forces.

To the west, Second River (Belleville) was manned by Patriots. The spire of the Dutch Church at Second River was used as a lookout and a sharpshooters' nest by Captain Abraham Speer and his contingent of militiamen and regular army.

On September 14, 1777, British General Campbell attempted to pass through Second River but was detected by the spire watch. On the eastern bank, observing and holding as a reserve, was Sir Henry Clinton. A defense was prepared by Captains Joralemon, Rutgers, Hornblower and Rutan, and it began with an artillery barrage. Much of the fighting lasted for two days, with scattered skirmishes throughout the local farms and nearby present-day Mill Street and Union Avenue. Patriot reinforcements arrived from neighboring communities, but British forces eventually pushed through to Acquackanonk. During this time, the battle of Saratoga, New York, would begin and end with a decisive Patriot victory in October 1777.

The Second River Church (Belleville, New Jersey) Graveyard memorial to sixty-six American Patriots buried there.

The common local militiamen (not regular army) could only hope to harass and contain the British and their Loyalist friends. Nearby, Patriot Captain John Outwater mustered a local militia as one of the twenty-five that had been authorized by an act of the state assembly in 1776. Companies like Outwater's were mainly farmers fetched from each locality and commanded by a local officer. In Hackensack, Outwater's company patrolled the banks of the Hackensack River for privateers trading with the enemy in New York.

The surrender of Cornwallis at Yorktown in 1781 erased most expectations of a British victory. But it took an additional two years to agree to peace terms and evacuate armies from New Jersey and New York. The Treaty of Paris was signed on September 3, 1783. Some of the best accounts of the war's local effect on New Barbadoes Neck are included in Adrian C. Leiby's *The Revolutionary War in the Hackensack Valley: The Jersey Dutch and the Neutral Ground.*

THE INDUSTRIAL VILLAGE OF PATERSON FOUNDED

With the end of the Revolutionary War, the country threw off the economic shackles of a colony and slowly assumed the responsibilities of a new nation. Although agriculture was still the dominant sector of the economy, it soon became apparent that industry would drive the future. Raw materials, skilled labor and ready capital were now becoming more available, but to run an efficient manufacturing mill, a source of reliable power was needed. No one understood the nexus of all these forces more than Alexander Hamilton.

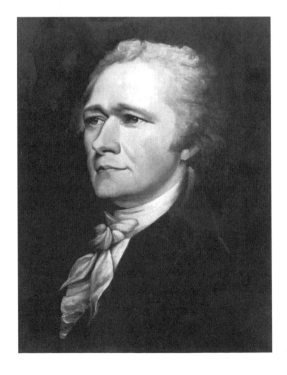

Alexander Hamilton, father of Paterson industry.

During the war, Colonel Alexander Hamilton was an aide-de-camp to George Washington. In July 1778, while en route to Paramus, General Washington, the Marquis de Lafayette and Hamilton rested at what was then called Totowa Falls. Hamilton noticed the natural beauty but was overwhelmed by the potential power of the "Great Falls." After the war, he was appointed secretary of the treasury. He was a proponent of concentrated industry and a federal banking system and had one specific place in mind for his "New National Manufactory." He detailed his ideas to Congress in 1790 with the result that the New Jersey legislature passed a law establishing the charter of "the Society for Establishing Useful Manufactures," or SUM. It would be the first incorporated business charter in New Jersey, and Hamilton was its most fervent adviser and volunteer. The area was named Paterson in honor of New Jersey Governor William Paterson, who supported the project. In addition to the ready source of power, the town was at a crucial point in the Passaic River. Importing raw materials into Paterson mills was as important as being able to ship finished goods out to the world. Over the years, it would become one of the nation's dominant centers of industry for the manufacture of paper and clothing silk, as well as metal forging. Eventually, the city of Paterson produced the vast majority of the nation's locomotives.

JOHN RUTHERFURD

The Borough of Rutherford was the namesake of American lawyer, politician and land speculator John Rutherfurd. John Rutherfurd was born in New York City on September 20, 1760, to parents Walter and Catherine Alexander Parker Rutherfurd. Walter was a British army veteran of the French and Indian War. During the Revolutionary War, it

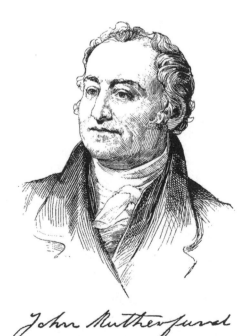

U.S. Senator John Rutherfurd. *Courtesy of the United States Senate.*

seems he was sympathetic to the Patriot cause but refused to turn against his Loyalist history and attempted to remain neutral. For that, Walter was taken hostage in 1777 by the Americans to be used as a bargaining chip in a prisoner exchange. He was held during most of the war in Morristown.

In 1776, and then during most of the war, his son John studied law at the College of New Jersey (now Princeton University). He became more closely aligned with the Patriot cause by associating himself with New Jersey politicians Richard Stockton and William Paterson. His collaboration with state and national leaders seemed to propel him into politics. He began by serving in the 1788 New Jersey General Assembly. But three years later, he was elected as an early Federalist to represent New Jersey as its second United States senator. During the Washington administration, he served in the federal office from 1791 until resigning on December 5, 1798.

Retired from politics, John Rutherfurd was still called upon to undertake many important civic and business projects during the rest of his long life. He assumed the presidency of the East Jersey Proprietors in 1804, and remained in that position until 1840. From 1807 to 1811, he formulated the planning for the New York City street grid for the area north of 14th Street. He developed the concept of a canalway connecting the Delaware, Raritan and Hudson Rivers.

In 1808, John Rutherfurd moved his family to a farm on the banks of the Passaic River near what is now the Bergen County Park in Lyndhurst. He named his beloved estate "Edgerston" after the area associated with his original clan in Scotland. While pursuing all of his numerous projects and financial empires, Rutherfurd resided on the banks of the Passaic for the rest of his life. He died at the estate on February 23, 1840, and is buried in a family vault in the cemetery of Second River Christ Church, Belleville.

New Names for Old Places

In 1825, the New Barbadoes area was subdivided into smaller townships named Saddle River, Harrington and Lodi. What is today Rutherford became part of Lodi Township. Then on February 22, 1840, the Greater Rutherford area that was part of Lodi Township was transferred by an act of the New Jersey Council and General Assembly to newly formed Hudson County. With this new county came a name change for this area now to be known as Harrison Township. After formation of both Passaic and Hudson Counties, the original County of Bergen was left with less than 50 percent of its previous population, and the remaining landowners were handed another alienation from their familiar courts and government. It took another dozen years for the local people to successfully petition to be returned to the County of Bergen.

Finally, in 1852, Union Township was formed from areas of Harrison and Lodi Townships that had been reunited with Bergen County. The area (contained by present-day Rutherford) assumed the colloquial name of Boiling Spring, and the "Old Indian Trail" (Union Avenue) was now commonly called Boiling Spring Lane.

As described in the 1876 Walker Atlas of Bergen County, the first meeting of Union Township

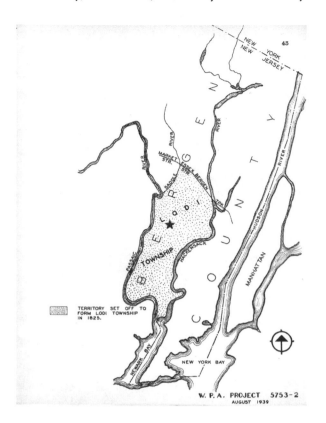

A WPA map of Lodi Township, 1825.
(The star indicates the Rutherford area.)

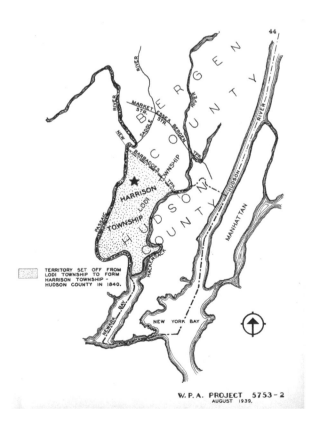

A WPA map of Harrison Township,
1840. (The star indicates the Rutherford
area.)

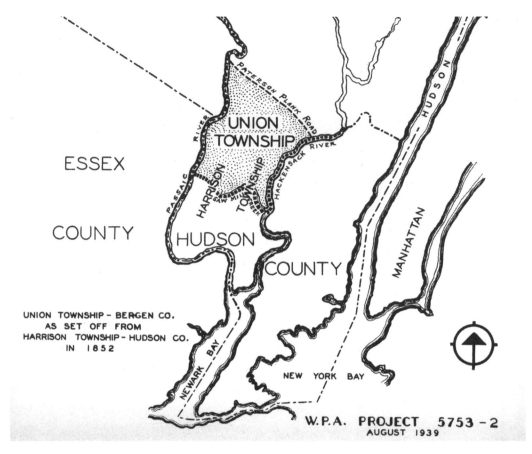

A WPA map of Union Township, 1852.

was held in the old school-house on Riverside April 16, 1852; The township officers elected Town Clerk Aaron Hazen; Assessor, John V.S. Van Winkle; Collector of the Taxes, Henry H. Yereance, Chosen Freeholders, Henry Kip, Cor's. C. Joralemon; Town Committee, Joseph K. Hazen, Robert Rutherfurd, Tunis A. Brown, Joseph M. Roy, John L. Vreeland. The total amount of taxes raised in the township for that year was $1397.08.

OF ARRIVALS AND DEPARTURES

Roads, Rivers, Rails and New Settlers

Transportation was the new American Revolution, and its vanguard was the railroad. New roads and the rails moved people, drove commerce and brought speculators and residents to Rutherford. With the ebb of slavery came the rising tide of conflict between the states.

If one were to consider all of the history of the Borough of Rutherford, what would be the single most important change that affected the town? Beyond all other events, the late seventeenth-century arrival of roads, and the arrival of the railroad in the 1830s, had the most dramatic effect on the area, even to the present.

RIVERS AND EARLY ROADS

There were no true roads in the Bergen County area until the beginning of the 1700s, and there were no bridges over the wide Hackensack River until 1720. Some of the reasons were obvious, as ferries were privately operated, required low capital and could be moved or even retracted for defense. A bridge required skill and money to build so it then needed to be a publicly maintained conveyance and generally remained stationary. At many points, the Passaic River was easier to cross and navigate than its easterly sister, the Hackensack. Most river crossings were made by self-piloted boats or by rope-guided ferries, such as the one established at Acquackanonk Landing as early as 1682. At this important crossing, a ferry system was used until it was replaced by a crude wooden plank bridge in 1741. Eventually, in June 1766, there was a legislative act "to empower the Justices and Freeholders of Essex and Bergen Counties to build a bridge on the Passaick River near the Dutch Church at Acquackanonk." On the Bergen County side, this proposed bridge was close to the home of Waling Van Winkle, a grandson of our settler Waling Jacobs. As was previously mentioned, the bridge was frequently referred to as the "New Bridge at Wallences." Little did Mr. Van Winkle know that just ten years later this bridge would play a monumental role in the birth of the United States.

During most of the eighteenth century, only two roads ran through the Rutherford area. They were the east–west Old Indian Trail (Union Avenue) and the north–south riverside road (Riverside Avenue). As may be imagined, these roads did not always have fixed names. Travelers went from one point to another on the path of least resistance, stopping to ask what was ahead if humans appeared. The Neck or Newark Road (now known as Meadow Road) may have been part of another long Native American path system that skirted along the meadows close to farms and settlements. Eventually, it was officially commissioned and mapped. In 1794, at the June term of the Court of Common Pleas for Bergen County, surveyors were appointed at the request of the freeholders of Bergen County to lay out a road three rods wide (fifty feet across) "running southeasterly from Boiling Spring Road to Schuylers Road or Sedor [sic] Swamp Road, the latter leading from Arent Schuyler's land across the neck to the Cedar Swamps." "The Neck" may have only told a traveler that he was on a roadway in New Barbadoes Neck, but the more aptly named Newark Road actually held the promise of a destination. Then, as today, Newark Road intersected with Hackensack Road (also Polifly Road) right at present-day Rutherford. One might even imagine a signpost!

Which came first: the road or the house? Was a road made to go past a frontier home or was a house built close to a road? Clearly, proximity was important. As Bergen County historian Kevin Wright notes, "Most original homes were not set in the middle of a lonely field but rather within 'chatting distance' to a thoroughfare." Roads not only conveyed commerce but also drove information, news and social connection. With the constant need to travel between waterways, crops, commercial centers and other farms established, roads needed to be set out and maintained. In the beginning, with repeated use by animals and humans, common trails and pathways eventually became somewhat passable roads. In time, local governments would require an organized "call out" for each landowner to work on his adjoining road frontage. Clearing a road required felling trees and then removing their stumps and boulders, all by hand, for whatever length required.

In 1716, a second route was established in the Rutherford area. It was a road two rods (thirty-three feet) wide, cleared to run from the path close to the northeast corner of Waling Jacobs Van Winkle's house near the Old Indian Trail (later Union Avenue) north to the boundary of Jacob Van Norstrand's farm, or nearly to present-day Paterson Plank Road. The northern part of this road was redirected and partially abandoned, but eventually this farm connection would encourage trade. This route was further extended south to run to a Passaic River crossing over to Belleville. Today we know this route as Riverside and Jackson Avenues. Jan Jurianse (ancestor of the Yereance family of Rutherford) purchased property alongside this roadway in 1711. It is not known when he actually occupied this farmland, but his will of 1753 refers to a house at the location of today's West Newell and Riverside. As this river route became more traveled, more Dutch farmers would settle close to it.

From the 1790s to the mid-nineteenth century, most of the settlements in the Boiling Spring area were concentrated on a road that bordered the meadows. First known as Neck Road, then Newark Road and finally Meadow Road, it was where the village of Boiling Spring began to populate. Whether it was the nearby source of water,

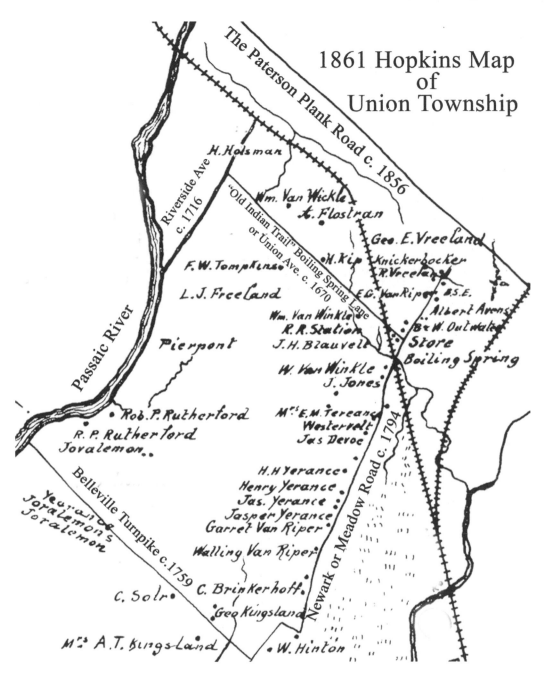

1861 Hopkins Map
of
Union Township

The Paterson Plank Road c. 1856

H. Holsman

Wm. Van Wickle

A. Flostran

Riverside Ave c. 1716

"Old Indian Trail" Boiling Spring Lane or Union Ave. c. 1670

Geo. E. Vreeland

H. Kip

Knickerbocker

R. Vreeland

F. W. Tompkins

E.G. Van Riper

B.S.E.

L. J. Freeland

Albert Arens

Wm. Van Winkle

B. W. Outwater

R.R. Station

Passaic River

J. H. Blauvelt

Store

Pierpont

Boiling Spring

W. Van Winkle

J. Jones

Rob. P. Rutherford

M.rs E. M. Tereance

Westervelt

R. P. Rutherford

Jas Devoe

Joralemon..

H. H. Yerance

Henry Yerance

Belleville Turnpike c.1759

Jas. Yerance

Yeurance

Joralemon's

Jasper Yerance

Joralemon

Garret Van Riper

Newark or Meadow Road c. 1794

Walling Van Riper

C. Solr.

C. Brinkerhoff.

Geo Kingsland

M.rs A.T. Kingsland

W. Hinton

An 1861 Hopkins map, altered to show the established roads and Newark Road (Meadow Road) settlements.

the closeness to game in the open meadows, the proximity to the early railroad, the commerce that flowed along the main road between Hackensack and Newark or all of these factors and more, people were attracted to this strip of land and the beginning of a new community.

As would be expected, most of the names along Newark Road were Dutch, as in Van Riper, Yereance (a branch of the Van Riper/Van Reyper family who derived their surname from the Dutch patronymic "Jurianse"), Brinkerhoff and Van Winkle. On the 1849 *Sidney Map of Twelve Miles Around New York* there are some fourteen family-named sites, with a slight increase in families on the *Hopkins Map of 1861*. One of the most important structures is noted on Hopkins as "W. Van Winkle." It exists today as the Kip Homestead at 12 Meadow Road. The original Kip (sometimes spelled Kipp) family was French (probably "de Kype") but came to New Amsterdam in 1635 from Leyden, Holland. Much of the Kip family remained in New York, but many emigrated west and north.

Architectural evidence suggests that about 1770 Peter Kip or his son Hendrick erected the present sandstone structure. It has been modified over the years, and was eventually owned in 1852 by Daniel Van Winkle. The Kip Homestead represents Rutherford's oldest extant Dutch sandstone house and was a center for the start of the Boiling Spring/Rutherford area. It is believed that the Kips probably established the town's first school around 1819. The second school was erected on the property sited opposite this house on the east side of Newark Road near Passaic Avenue. Daniel Van Winkle's neighbor James P. Jones opened the second school on April 19, 1852, and served as its first teacher.

At one time, there were as many as six (or even more) Yereance family houses along this road; however, the absence of clear provenances for at least two puts the number in question. Extensive research by former borough historian Frederick Bunker and others has not yielded the answer to the question of which might have been the house of the original Yereance—Jurie Jurianse, who adopted the rather anglicized name of Jeremiah Yereance—dating from the early eighteenth century. One possible site is the house at the corner of Crane Avenue (91 Crane), now the Meadowlands Museum. Known as the Yereance-Berry House, it was described in the 1981 Bergen County Historic Sites Survey as originally owned either by John W. Berry (a descendant of one of the two original landholders) and built approximately 1804, or by Jurie Jurianse and built circa 1740, which would make it the oldest extant house in the borough. Built on a traditional red sandstone foundation, its early Federal period appearance seems to indicate an early nineteenth-century origin. The Historic American Buildings Survey of 1938 weighed in on the side of John Berry and 1804. Bunker asserted that there was no evidence that it was ever a Yereance house and postulated that it might have been built as late as 1818. Clifton historian William Smith researched the area and stated that the other contender for the circa 1740 Yereance house was a structure at 251 East Pierrepont Avenue. In the 1981 Bergen County Historic Sites Survey it was historically known as the Henry H. Yereance House. The house, razed in 2005, may have been built upon the foundation of the original Yereance house, but, again, there is no conclusive evidence.

Unfortunately, it may be that only the Kip Homestead remains as witness to the line of original family homesteads and the community that once dotted the connecting roads from Hackensack to Newark.

Crossing the Meadow

All roads, land and water seemed to coalesce as the country focused its industrial strength on improving transportation. On Saturday, May 31, 1856, it was reported in the *Falls City Register and Paterson & Bergen Advertiser* that "the Plank Road between this city and Hoboken will be opened on next Tuesday…when it is expected that NJ Governor Price, New York City Mayor Wood and others will be present." The "Paterson Plank Road" was constructed to cross the meadows and wind down the Palisades into Hoboken. Historically, "the meadows" was an ecological barrier (some would say it was the biggest isolation fence in New Jersey) that prevented easy access to transportation from the Hudson River to most of the area in New Barbadoes Neck. Typical of plank roads of the era, it was thirty feet wide and built of wood planks (cedar when possible) two inches thick and eight feet long. These were nailed to buried four-inch-square stringers. Small villages would grow beside the road near bridge crossings and other bottlenecks.

THE ADVENT OF "RAIL ROADS"

The New American Revolution

As early as 1810, roadways consisting of parallel wooden rails using gravity- or animal-driven loads were being crudely constructed in mining areas of Pennsylvania. After the War of 1812, new engineering concepts and the urgent need to improve transportation empowered the ideas of John Stevens from Hoboken and other New Jersey visionaries. The "railroad" industry made quick progress, even though it was in fierce competition with the somewhat more established canal waterways epitomized by New York's Erie Canal, opened in 1825, and New Jersey's Morris Canal, opened to Newark in 1832.

The Paterson & Hudson River Railroad Company (P&HRR) was incorporated January 21, 1831, and commenced operation in June 1832. At first it ran a route from Paterson south to Acquackanonk Landing. It consisted of "three splendid and commodious cars, each capable of accommodating thirty passengers, drawn by fleet and gentle horses; a rapid and delightful mode of traveling." The transition away from animals to powered locomotion must have been quick, but it also brought with it some misgivings, for it was soon advertised that "the steam and horse cars are intermixed so that passengers may make their selection, and the timid can avail themselves of the latter twice a day." Steam power was also being applied to navigation as the boats *Newark* and *Passaic* were introduced for travel on the Passaic River up to Acquackanonk Landing, then down and around Newark to New York City. So it seemed that just a few miles away from where the Schuyler Mines first demonstrated steam power to America, now, eighty-two years later, it came roaring home.

The railroad first passed through the Rutherford area in 1835, and the line reached the Hudson River in 1838. Coupled with the Hudson ferry crossings, it offered relatively quick, semi-comfortable and mostly reliable service to New York City. But a railroad passing through a village and stopping were two different things. Actual stopping required a reason to load or unload, or to take on fuel or feed and water for animals. So when the railroad engineers surveyed their proposed route, they found what all other

Paterson Hudson Railraod "pulled by fleet and gentle horses."

An 1834 Paterson Hudson Railroad carriage.

A Paterson Hudson Railroad engine, called the Whistler.

early pioneers found valuable in the Rutherford area—a ready and profuse bubbling, or "boiling," spring.

Now the rhythm of the area changed radically. When the depot bell was rung to signal the arrival of a train, all attention turned to the iron horse. First, with freight haulage, the railroad afforded a huge increase in economic possibilities. It presented a vista of transportation opportunities. Local farmers could bring large quantities of their produce to the Hudson and New York markets. Workers could migrate along the line to Acquackanonk, Paterson, the Hudson riverfront or even New York City. And then, with reliable passenger service, people could link to other transportation such as roads, stagecoaches, boats, ships and, soon, other railroads. A crude depot area developed near the "boiling spring" water supply and was arranged for loading goods and passengers. Accommodation services such as carting, livery stables, taverns, stores and blacksmithing spots soon grew nearby. Mail and printed materials could also be exchanged. The railroad's stopping point was in the same relative area as the present-day Rutherford Railroad Station. Since this loading area was close to the established Newark Road (Meadow Road), Hackensack Street and Boiling Spring Lane (Union Avenue), it soon became a hub of activity and commerce for the entire area.

Smartly, the City of Paterson vigorously sought to connect north with the New York and Erie Railroad (NY&E) to Suffern. This link would ensure that travelers from the west would pass through Paterson (and Rutherford) to finally arrive at New York City. Trains began running from Jersey City through to Suffern by way of Paterson in 1848.

By 1852, this railroad was known as the Main Line. With the completion of the Erie Tunnel in 1861, the NY&E would emerge from bankruptcy to be known as the Erie Railroad. Within thirty years of the introduction of the railroad, twenty-two rail lines were in operation throughout New Jersey. On May 10, 1869, at Promontory, Utah, the last spike of the country's first transcontinental rail line was hammered home.

THE NEW YORKERS ARRIVE

Throughout the larger area, the names would not remain Dutch forever. As the railroad became more reliable, it increased interest in the Boiling Spring area. There was the usual migration from the shore of Hudson County, but now New Yorkers looked toward southern Bergen County as a rural retreat from the overcrowded and too often unhealthful environment of their city lives. Some would arrive just to "summer in the country," but many of them found ways to stay for good, year-round. Some would even try their hand at the area's oldest profession, real estate speculation.

The "Punkin Dusters" (the rather unflattering moniker given to the long-established, primarily Dutch-American farmers) looked at the mid-nineteenth-century arrival and land dealings of Floyd W. Tomkins with uncomfortable suspicion. Today he is considered an important founder of Rutherford. The following are Tomkins's own words, as excerpted from Margaret Riggs's 1898 book, *Things Old and New from Rutherford*:

April 2, 1858, I moved with my family [wife and five children] *to Boiling Spring as it was then called, and made our home in the little stone cottage on the hill on Union Avenue just above Montross Avenue having bought it with twenty-five acres of land. In a short time I bought 76 acres more on Union Avenue and had it surveyed and a map made of The Villa Sites at Boiling Spring, Bergen County N.J.*

Tomkins originally came from New York, and he recognized early on the quality of life that could be enjoyed in the little village of Boiling Spring in the township of Union. His "little stone cottage" became one of the most important structures in the town. Originally, the site was part of the Van Norstrand property. It was purchased in 1798 by Christopher Yereance, who immediately sold off one acre to his son Hesel. As stated in the 2006 Revised Bergen County Historic Sites Survey, "Yereance built the house about 1810 and his family sold it in 1848. Subsequent owners included Cornelius Berdan, Edwin Randolph, and then Floyd W. Tomkins." Today this building is known as the Yereance-Kettel House and is splendidly extant as the eastern portion of the two joined houses at 245 Union Avenue.

Tomkins also appreciated the potential value of land in a town so closely connected to Hudson County and New York City. Together with Daniel Van Winkle and James Barclay, he began to collect parcels of farmland and offered them for sale in 1862.

The next ten years were an extremely important and active period in Rutherford's development; however, a large cloud shadowed everything at the start.

OF A NATION DIVIDED, A VILLAGE UNITED

Even as the country was torn and wearied by the War Between the States, Rutherford was energized and driven by growth, success and optimism for its future.

THE CIVIL WAR: A NATION, A STATE AND NORTHERN NEW JERSEY

The Lincoln Debate

In the 1860 presidential election, New Jersey was one of the few states to provide a victory for Stephen Douglas over Abraham Lincoln. Just four years later, while in the throes of a civil war, New Jersey again diverted its electoral votes from the popular President Lincoln and toward a new resident of the state of New Jersey, General George McClellan. New Jersey became the only free state to reject Lincoln twice.

New Jersey Enlists

Today, we cannot fathom open warfare within our country's borders. In fact, before the start of the Civil War most Americans believed that any rough conflict would be short, decisive and finally put to permanent rest. But in 1861, only eighty-five years after the Declaration of Independence, another fight for freedom entangled the entire nation. As the cataclysmic events built toward war, New Jersey had, for the most part, eliminated the practice of slavery. Still, it was an inconvenient truth that the state relied upon materials from the slaveholding South to process in its mills and factories. It also exported finished products south of the Mason-Dixon line. No one wanted the disruption of a divided country, however long or short. Sadly, the majority, which believed a serious conflict would result in a transient standoff and not a war, was proved to be dead wrong.

Over 88,000 soldiers from New Jersey were part of thirty-one infantry and cavalry regiments mustered during the Civil War. Four state militia regiments, three cavalry regiments and five batteries of light artillery were formed. By comparison, 23,116

Abraham Lincoln.

soldiers from Virginia, Maryland and the District of Columbia served in the Union's Army of the Potomac (later the Army of Northern Virginia). New Jersey soldiers primarily fought in the Eastern Theater of the war. Over 6,000 soldiers from New Jersey lost their lives in the conflict. Many perished valiantly on some of the most horrendous battlefields of the war.

Northern New Jersey: Citizens and Industry

The Northern cities of Paterson, Newark and Camden, New Jersey, and much of their surroundings, grew financially strong with the increased demands on their core industries. Paterson mills produced necessities, including clothing, paper and metalware, and war materiel such as ammunition, guns and locomotives. It was around 1814 that Isaac Van Winkle established a small mill close to a natural pond that drained into the Passaic River. This mill was located on top of a small rise in the present Carlton Hill area of East Rutherford. Used for "fulling and dyeing and sawing," this mill may have been the first industry in the immediate area besides the Joralemon shipbuilding yards and the Schuyler Mines located at the southern end of Union Township. Isaac was born in 1767 and was a direct descendant of the original settler Waling Jacobs. The mill was known as the "Van Winkle Mill in Union Township, Bergen County, near Acquackanonk." With the arrival of the railroad, the mill area expanded and other buildings were erected. This mill area was known as the Boiling Springs Bleaching Company. It would change ownership several times and eventually evolve into the larger Standard Bleachery factory system near the corner of Erie and Jackson Avenues in East Rutherford. As the Union army demanded thousands of uniforms, tents and fabric coverings, local mills such as this became crucial to the Northern war effort.

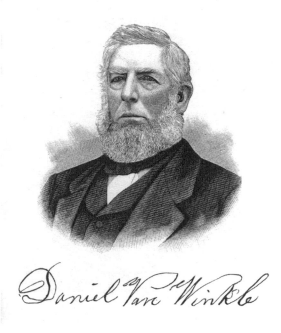

Daniel Van Winkle. *Courtesy of the Bergen County Historical Society.*

Daniel Van Winkle was born in 1816, the tenth child of the aforementioned Isaac and his wife Sarah ("Salome Van Winkle"). Daniel was already forty-five years old when the Civil War broke out, but he was plenty young enough to be one of the most dynamic and influential citizens in the formation of Rutherford. During the middle of the century, he acquired land surrounding the newly established railroad depot. It was Daniel who deeded the land for the Erie Railroad station and for Erie Avenue from Union Avenue to Meadow Road. The railroad station deed included a reversionary clause requiring that, in the event that the station was demolished, destroyed or abandoned, the property would revert back to the Van Winkle heirs. He also donated the land on which the original Union Hall was built. Daniel's first son was Arthur Ward (A.W.) Van Winkle, who was born on the eve of the new year of 1850. A.W. would carry on his father's legacy, first by tending the general store and then in real estate and community development. He erected the important Van Winkle Building (extant but very changed) at the western foot of Orient Way on Station Square. Early on, this sturdy, picturesque structure was the welcoming point for arriving train passengers from the east.

The Civil War returned soldiers home as civilians in many different conditions. Some were broken in bone and spirit, and some found renewal and changed lives.

RUTHERFORD RECOVERS FROM THE CIVIL WAR

Following the war, Rutherford author Warren Lee Goss (1835–1925) gave the world the popular and disturbing book *Recollections of a Private*. Begun as a series of articles for *Century Magazine*, his recollections were graphically realistic and remain among the most

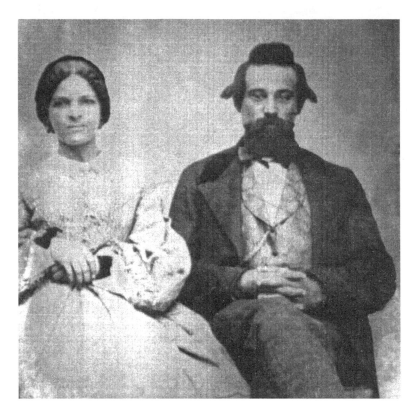

Harriet and Lafayette Hoage.

important accounts of the Civil War and Confederate prisons. In November 1861, at age twenty-six, Goss had enlisted as a United States Army private. Originally a clerk and Harvard student from Boston, he was listed on the roster of the Second Massachusetts Volunteer Heavy Artillery Company H as a sergeant. Remarkably, he was captured twice during the war and held prisoner at Belle Island, South Carolina, as well as the infamous Andersonville prison camp. He was exchanged in 1864 and mustered out again on September 11, 1865. After the war, Mr. Goss penned many recollections of his service and came to Rutherford to live at 78 Chestnut Street in 1896. He authored eleven books and many magazine articles, some of which were illustrated by the popular cartoonist Thomas Nast.

According to local historian Rod Leith, another one of Rutherford's illustrious Civil War veterans, Lafayette Hoage, was born into slavery in 1837. During the war, he had been an assistant to army Captain Alonzo Mabbett and traveled with the captain to upstate New York, where he met his future wife, Harriet Elizabeth Henon. Lafayette and Harriet moved to Boiling Spring in 1867 and purchased two property lots from the Rutherfurd Heights Association. He built the Italianate-style house still extant and preserved at 127 Donaldson Avenue. The Lafayette Hoage House embodies an important story of an African American family after the war. At some point, Lafayette began to work for David Ivison as a coachman and landscaper. He tended to Ivison's coach and horses in a barn behind the Donaldson House. Lafayette and Harriet had seven children, one of whom was named Rutherford. Another son, David Ivison Hoage,

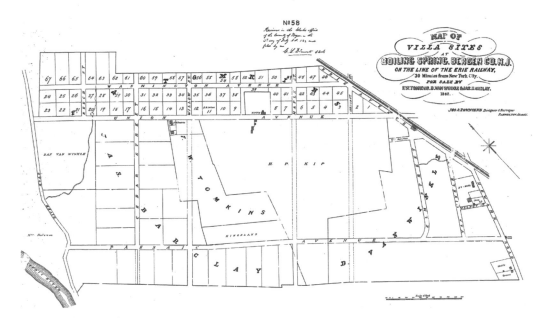

Villa Sites at Boiling Spring.

became a doctor in New York. Daughter Lillian Hoage inherited the family home and held onto it until 1935.

Despite the fact that during the Civil War many people in Boiling Spring were able to profit from the upswing in Northern industry, when money was made it needed first to be secured and then securely invested. The Rutherford Mutual Building and Loan Association was formed in 1876 with a year-end net income of $4,137.82. Investors deposited their money into secure interest-bearing accounts, and these funds were used to finance property and home-building loans. This institution allowed more people the ability to acquire property and do simple banking functions locally. Many of the more wealthy investors pooled their resources to form land associations to acquire large tracts of property to develop.

AMID THE STRIFE

The Land Associations of Rutherford Are Born
Available for inspection in the Bergen County Clerk's Office is a collection of important maps that chart the formation of Rutherford as a residential community. One of the earliest is the 1862 Map #58 of "Villa Sites at Boiling Spring, for sale by F.W. Tomkins, D. Van Winkle and Jas. Barclay." It was the first map of a true land association in Boiling Spring and describes an ambitiously large area running east from Newark Road all the way to River Road (Riverside/Jackson Avenues) and north from Passaic Avenue almost to present-day Erie. Most of the area is made up of large, individual land tracts belonging to Tomkins, Barclay and Daniel Van Winkle, with their residences noted. Next to Mr. Van Winkle's home on Newark Road (extant at 12 Meadow Road) is the Jones residence, and

on the opposite side is a small square that denotes the second schoolhouse in Rutherford. The F.W. Tomkins home on Boiling Spring Lane was now on the newly named Union Avenue, and the farm and home of H.P. Kip, as well as the D.B. Ivison estate, also front on Union Avenue. (The name change was probably made in empathy with both the existing Union Township and the opening war effort to preserve "the Union.") The map shows a checkerboard of proposed land plots for sale, mostly on the south side of Union. New names for proposed streets were "Willow" (now Montross), "Cedar" (Carmita), "Elm" (Orient Way) and "Van Winkle" (possibly Eastern Way). Villa Sites was the first large-scale attempt to plan an expansive community in Boiling Spring.

On Maps #95 and #96 are the lands developed as the "Rutherfurd Park Association Situated on the Passaic River, Union Township, 1867." The Rutherfurd Park Association, headed by Robert W. Rutherfurd, acquired from William J. Stewart a large parcel of land in the southwestern section of Union Township bordering on the Passaic River. Much of this property was south of Pierrepont Avenue and distant from the important railroad. The association had a grand scheme: it would project a wide, well-maintained road from the newly established Valley Brook Race Course (within present-day Lyndhurst, north of Valley Brook and east of Riverside Avenue) to the growing railroad station at Depot Square in Boiling Spring. On March 4, 1867, the New Jersey state legislature passed the act authorizing the improvement of the road aptly named Park Avenue. This new direct route would be an alternative to leaving the depot, traveling down Union Avenue and turning left to ride along dusty old Riverside, and it was shorter by almost half. The association also erected the Rutherfurd Park Hotel for $110,000 to join Majors Hotel in enticing vacationing New Yorkers into inspecting possible property lots for investment and/or year-round residency. On Christmas Eve 1870, the Rutherfurd Park Hotel was totally lost to fire. The *New York Times* reported that it was "supposed to have been started by an incendiary."

In 1867, surveyors proposed a public road fifty feet wide to run east and parallel with the Erie Railroad right of way. From the intersection of Newark Road (Meadow Road) and Hackensack Street to the intersection of Union Avenue at the depot, Erie Avenue would now serve as a vital and well-trodden connector of Newark Road to Union Avenue.

The map for the "Property of Mount Rutherford Company situated at Rutherford Park" was first filed in Bergen County in June 1867. Then an almost exact copy was re-filed in June 1868. The Mount Rutherford Company collected much of Daniel Van Winkle's land south and east of the railroad depot that was somewhat centered on the land rise of "Mount Rutherford" (The Terrace). The topographic difference between the maps seems to be a reduction of a small hill near the depot encompassing today's Ames Avenue. At the top of this hill was the original Union Hall. This building was the social center of the village and, from contemporaneous accounts, seems to have been so well esteemed that it was preserved and moved down the hill to front on level land on "Union Hall Place" (Ames Avenue). The soil taken from this area would be used to re-grade much of the land association's domain. Also, an area from Park Avenue to Feronia Way and from Glen Road to Spring Dell was further contained as a pond known as Glen Waters and also called Sylvan Lake. Some of the source of this pond was the runoff from Mount Rutherford, but most likely it was primarily a collection point for the "boiling springs" that ran wild all over the Depot Square area.

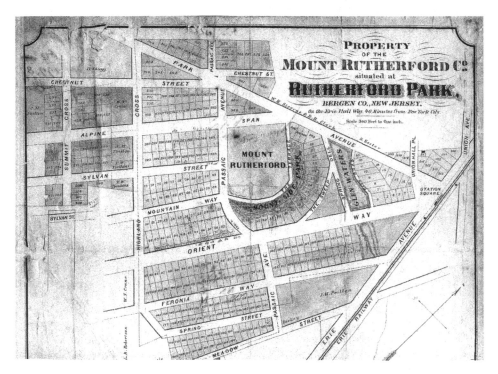

A map of Mount Rutherford Company.

Rutherford Land Association 1862 –1896

A. Villa Sites at Boiling Spring, 1862
B. Property of the Rutherfurd Park Assoc. 1867
C. Property of Mount Rutherford Company, 1868
D. Rutherford Heights Association, 1868
E. Property of the Home Land Company, 1870

F. Rutherfurd Home Assoc., 1872
G. The Shelter, Rutherford Park, 1872

H. Tho's R. Agnew at
 Rutherfurd Park, 1873
I. Rutherford Terrace, 1892
J. Summit Heights,
 Eibe D. Cordts, 1896

A composite map of Rutherford Land Associations.

Throughout this undulating land association, streets were projected out from the proposed Orient Way, Park Avenue, Erie Avenue and Alpine Span (now Ridge Road). On average, many of the 250-plus plots were simply 50 feet by 150 feet. The later map lists D.B. Ivison as the association president, but Floyd W. Tomkins was "the life of the Mount Rutherford Company" and Boiling Spring itself. Tomkins often personally gathered other interested New Yorkers together via the railroad depot to further the business of the Mount Rutherford Company.

On the map of the "Rutherfurd Heights Association," filed November 27, 1868, a few hundred lots were offered in the center of the growing town. This land company was headed by residents John Donaldson and Henry Bell. The map was surveyed by Boiling Spring residential civil engineer George Woodward. The association's area was loosely bordered by Union Avenue down to Riverside, up Newell to Park Avenue, back west via Passaic Avenue and north up to Carmita. Across from a part of the Rutherfurd Heights Association was a small pond within the northeast corner of Beech and Union. It was not big enough to stretch all the way north to Washington Avenue, but it did feed a creek that ran along the aptly named Springfield Avenue to end near Francisco Avenue. The area that surrounds today's Union School was a large expanse of farmland owned by J.P. Cooper.

The Heights Association streets were subsequently macadamized by Gettysburg veteran E.T. Galloway. Galloway acquired property on the bank of the Passaic River near the foot of today's Woodward Avenue and established a dock and bulkhead to assist his raw material handling and coal supply company. His was one of several small industrial sites fronting Riverside Avenue with river access. Galloway worked a small stone quarry between the rocky ridge that ran west between present-day Woodward and Donaldson Avenues and even experimented with an aerial wire trolley to transport rock quarried off the ridge and down to his dock.

The "Home Land Company, Rutherfurd Park," filed its map on February 21, 1870. This land company offered about 170 of the usual 50-foot by 150-foot lots in a smaller

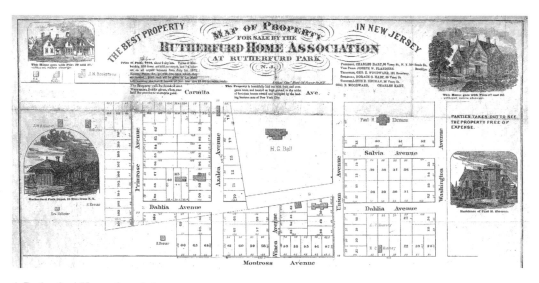

A Rutherfurd Home Association map.

but more valuable area between Park, Home, Chestnut, Ames and Union Avenues. All the property around the railroad station was drawing attention and attracting traffic. In 1873, by an act of the state legislature, final approval was sought for the grading of Orient Way, Ridge Road and Rutherford Avenue.

The decade saw the appearance of other land associations and development companies, even if they were just to exist on paper. They included Rutherfurd Home Association, Park Land Company, West Carlstadt Land Verein, East Rutherford Land Association, West Rutherford, the Shelter and Tho's R. Agnew at Rutherfurd Park. Most of these land companies made sure to mention that the town was anywhere from twenty to forty minutes away from New York City and situated at the first stop on the railroad. The Home Land Company map even stated that the annual railroad commutation cost was $49.25.

"Boiling Spring," "Rutherfurd" or "Rutherford"?

Yes, you have correctly observed (above) that the locality's name underwent curious changes. In approximately 1866, the simple name of Boiling Spring was cast aside for the more interesting Rutherfurd, with a "Park" sometimes added for good measure. Certainly, this name commemorated the Rutherfurd family. But now a more common usage was becoming "Rutherford Park" or just "Rutherford." Many explanations have been proposed regarding the letter substitution. One relates the name change to an innocent misspelling during the establishment of the new United States Post Office or train station. Another theory cites the rise of the Van Winkle real estate empire ("Mount Rutherford Co. at Rutherford Park" near the train depot) versus the waning influence of the Robert W. Rutherfurd family and their large landholdings (Rutherfurd Park Association, south of and removed from the still-to-be-projected Rutherford Avenue). Another theory purports that the change was finally made in honor of Rutherford B. Hayes, the future president and a certified Civil War hero. By 1869, Boiling Spring, Rutherfurd, Rutherfurd Park and Rutherford all become both common and legal names describing parts of the Union Township area and approximating the location of today's borough. As late as the April 3, 1872 issue of the *Bergen County Herald*, both spellings were used, along with or without the "Park" additive, on the front page. In 1875, "Park" was dropped from the name, and in 1881 the spelling was forever established as "Rutherford."

Station Square

As always, the railroad was the center of attraction for the town. Station Square was hardly ever just a square shape. At times it was a rectangle, triangle, circle and sometimes an indistinct patch of land. At times it was covered in weeds, flowers, mud, dirt, stones, water, brick, cobblestones and, finally, macadam and asphalt. In *Things Old and New from Rutherford*, Floyd Tomkins describes the original rail depot around the start of the Civil War:

The railroad station was a triangular brick box at the corner where the trains stopped to take in water. The depot, a small gable roof, primitive shaped building, stood on the eastern side of the railroad at the corner of Union Avenue, at that day a mere lane.

Richard Shugg reminisced about the topography near Station Square in his essay "Rutherford in '62":

Looking westward from this depot two modest looking hills completely shut out a view of the lands lying beyond them. The more southerly one is now dignified by the name of Mount Rutherford, the other a smaller one arose in a depressed cone like shape directly back of the depot, although the lesser in size the more honored of the two, in that on its apex stood the emblem of the intelligence and spirituality of the village, Union Hall, the place of assemblage for the Union Church and Sunday School of Boiling Springs…Between these sister hills was a deep ravine at once giving greater height and dignity to the hills than is now perceptible, and effecting a complete drainage of a large section of back land. On the laying out and grading of the lands around the depot by the Mount Rutherford Company the smaller hill was cut down to fill up this ravine where it was crossed by Orient Way avenue and by the Home Land Company in forming the plateau through which runs Ames Avenue. A filling at Orient Way gave opportunity for the forming of a picturesque lake-like pond called Glen Waters, fed by living springs and fringed on its southern side by a cluster of noble elms…This lake was given to the town by the Mount Rutherford Company. Subsequently, however, it was filled up from the fear of its producing malaria.

The Van Winkle Building and Depot Square, as described in the 1876 *Walker Atlas*, was

erected by A.W. Van Winkle, Esq at a tremendous outlay. It is conspicuously situated directly opposite the Rutherford Depot. This block contains one of the largest and most

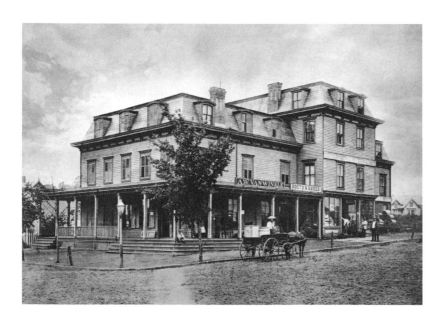

Van Winkle Building in Rutherford Station Square.

substantial stores in Bergen County, where every article in the line of dry goods, boots and shoes, groceries crockery, glassware, hardware, cutlery, agricultural implements, etc can be procured at reasonable prices. It also contains the post office, in charge of Mr. J.R. Collerd, an able and courteous assistant to Mr. Van Winkle. In the cellar of the building is a living spring of cold water, which furnishes a generous supply to the place. The handsome triangular green directly in front of the block adds greatly to its appearance, and the block as a whole is considered as one of the finest buildings in Bergen County.

A POST OFFICE

The Rutherford Post Office was first housed, about 1867, in a small, one-story building located on Orient Way near Glen Road. No business hours were set, and when Postmaster Richard Barrows closed the office, he took the mail with him. For his services, he received a salary of fifteen dollars a year. By 1869, a more permanent office had been established in Collerd's Store within the Van Winkle Building. The post office quarters moved several times, first to the McMain Building (extant at 11 Park Avenue), then to a site on the western side of Station Square and, finally, back to the Van Winkle Building. Banking facilities were scarce, and the post office would sometimes function as a note-cashing site. On October 1, 1889, the Rutherford Post Office was made an official money order office. But in 1894, the elusive post office was on the move again. Under Postmaster Alyea, it marched uptown to 62 Park Avenue but wandered back down to 19 Park about 1896. For a short time, the office would remain there.

Most postal patrons had no choice but to visit the post office in person to pick up their mail; however, it also served nicely as a community center where one could gather news, meet neighbors and get information. In the past, delivery to homes and businesses was addressed in terms of street intersections or placement. As an example, the address for

The first post office, on Orient Way.

John Rutherfurd's Edgerston estate was "East of Belleville on Passaic River." Use of house numbers spread slowly in urban areas but was mostly nonexistent in rural and semirural areas. With the advancements in record keeping made during the Civil War, the U.S. Post Office would eventually begin free door-to-door delivery of mail, contingent upon specific numbering of houses in well-defined municipalities. For Rutherford, this happened on September 1, 1897, as three regular carriers and two substitute carriers were appointed to carry the mail door-to-door.

In the mid-1870s, Rutherford still had large estates and working farms that were in daily use. The centrally located Kip Farm fronted on Union between Montross, Passaic and Home Streets and remained relatively intact until the next century. The fruit and berry farmlands of John and George Beard were centered on the extant structures of 96 and 86 Carmita Avenue and stretched across Montross, Erie and Washington Avenues down to Division Avenue (Jackson). Soon, these areas would be whittled down to fuel the fire of the land development and building construction engines.

BUILDING A TOWN BY THE BOOK: RUTHERFORD'S BUILDERS BUILD FOR A NATION

As the local land associations disposed of property lots, new owners sought out builders to erect their homes. The information-starved postwar nation sought new ways to live well, and people needed concrete examples of how their finished homes should look. Innovations developed before, during and after the Civil War aided the construction

An 1871 George E. Woodward Real Estate notice in the *New York Times*.

process tremendously. Lumber could now be milled in large, uniform quantities. Larger locomotives delivered boxcars full of wood, stone, glass and hardware. The rails could also import finished goods and interior furnishings. New architecture and engineering methods inspired great leaps of faith in design, and the advent of continuous roll paper fed the printers, which composed the newspapers, magazines and books containing the building plans. Rutherford had the benefit of all this and the creativity of its own "pattern book" designers.

Pattern books were born from the need to not only detail construction techniques to the building trades, but also to demonstrate current styles of architecture to property owners. American building guides appeared after the turn of the nineteenth century. In the late 1860s, the new idea of pattern books allowed homeowners a way to more fully participate in the choices in styling and construction of their houses.

George E. Woodward

One of the nation's most prolific pattern book authors was George Evertson Woodward. He lived in Boiling Spring and was well into his thirties when he began creating his series of design books. His brother, Francis W. Woodward, was a co-author and, like George, owned land in Boiling Spring.

The Woodwards' most influential pattern book was the 1869 *Woodward's National Architecture Containing Original Designs, Plans, and Details, To Working Scale, for City and Country Houses*, published by the American News Company (New York). The book is 170 pages in total and has one hundred detailed plates containing plans for house construction. Extant examples of Woodward designs in Rutherford are evident in the Hollister House

WOODWARD'S COUNTRY HOMES. WOODWARD'S COUNTRY HOMES. 169

FIG. 123.—*View of the old Farm House.*

FIG. 125.—*The old Farm House Re-modeled. Residence of George E. Woodward.*

FIG. 124.—*Plan of the old House.*

FIG. 126.—*Plan of First-floor improved.*

George E. Woodward plans to remodel Tomkins's "little stone cottage."

at 224 Hollister Avenue, from Plate #11 in *Woodward's Architecture and Rural Art* (1877), and the remaining Poillon House at 138 Meadow Road, possibly Plate #18, the "French Roofed Farm-House," from Woodward's 1868 *Architecture and Rural Art.*

While designing new Victorian homes on paper, Woodward was also remodeling one of the most important farmhouses on Union Avenue. As Floyd Tomkins built and moved his family to his new "Hill Home" (later incorporated into Iviswold—"The Castle"), he sold his beloved "little stone cottage" to George E. Woodward about 1866. The architect modernized the farmhouse and documented the process with illustrations in the last chapter of *Woodward's Country Homes.* Woodward sold the house and property to the Kettel family in 1876, and they owned it until 1954. George Woodward was also civil engineer for the Rutherfurd Heights Association.

E.C. Hussey

Elisha Charles Hussey was born in Ohio in 1832. He started to create his pattern books in the early 1870s. It is not known when he moved to Boiling Spring, but his most significant residence is extant at 134 Montross Avenue. Today, this house is very changed, but it most resembles design #6A in *Homes for Everyone.* Hussey was also listed as town assessor in 1874. His most successful titles were *Hussey's National Cottage Architecture* (1874) and *Victorian Home Building: A Transcontinental View* (1876), with eleven editions published by American News Company.

A Transcontinental View is also interesting as Hussey not only offers his pattern designs, but also makes extensive comment on resources and lifestyles of a line of towns across the United States. Rutherford is the first and most lavishly mentioned locality, and this reveals Hussey's love of his hometown. In addition, the Rutherford essay shows his desire to advertise the services of his friends, as the following comment attests:

> *Among the carpenters and builders, Mr. Samuel T. Hinks, has been in the place about nine years, and has executed some of the best buildings in Rutherford. He is a thoroughly trained mechanic, and has generally succeeded in giving satisfaction to his customers. He is now engaged, to some extent, in putting up buildings of about the class of plate No. 3, for sale; and is offering them at reasonable rates. His shop is but a short distance from the depot.*

The houses described as being built by Hinks are at 109 Mountain Way (extant as the T. Allaire House) and 143 Mountain Way (extant as the E.N. Crane House). Architect Hussey did not hold back on criticism. Describing the houses at 109, 113 and 115 Ridge Road (Plate #2 in *Victorian Home Building*), Hussey actually scolded builder Hinks by writing:

> *At Rutherford, NJ, may be seen three examples of this design. They stand on Ridge Avenue [sic] about ten minutes walk from the Depot. The owner placed them in a row, thereby very much damaging their general effect, by producing a monotonous appearance. We know of no design that will stand more than two examples in the same block, without detracting in some way from their desirableness.*

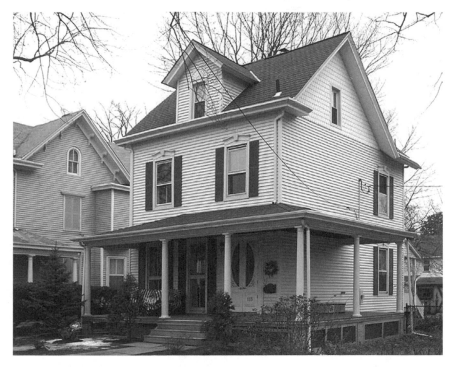

115 Ridge Road, designed from Plate #2, E.C. Hussey's *Home Building*

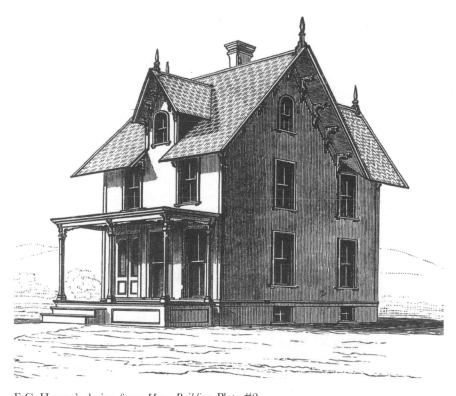

E.C. Hussey's design from *Home Building*, Plate #2.

Other Hussey designs, from *Victorian Home Building*, are evident at 287 Park Avenue (Plates #7, #15, #37), the A.W. Brigham House at 82 Woodward Avenue (Plate #15), 112 Chestnut Street (Plate #18) and 54 Maple Street (Plate #22). In the Bergen County Historic Sites Resurvey of 2006, architectural historian Jeanne Kolva stated:

> *The house at 242 Carmita matches exactly with design number 22 in Hussey's Homes For Every Body book. The illustrated side elevation has the identical slopes that exist today. I would make the claim that this house is the actual model for the illustration.*

E.C. Hussey was more than a contemporary of the more senior pattern book author George Woodward. The Woodward and Hussey households were literally across the street (Union Avenue and Montross) from each other, and their illustrator, Charles Spiegle, lived three blocks away on Union Avenue (behind today's line of retail stores on the western side between Carmita Avenue and Beach Street). They also shared a New York office, at 191 Broadway, and a publisher, the American News Company.

Hussey's house at 134 Montross was so prominent a landmark that it was used as the starting point for the Montross Avenue road improvement, which began literally at his doorstep. In 1875, the Court of Common Pleas of the County of Bergen appointed surveyors to lay out a public road commencing at "the Dwelling House of E.C. Hussey on the North East Corner of Union and Willow then running south on Montross Avenue to Pierrepont Avenue; thence to…"

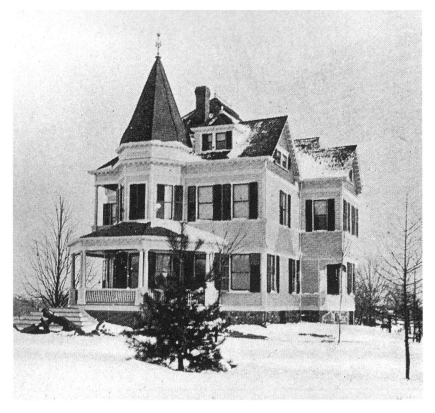

The Herman Fritz Dannheim residence, now Temple Beth-El.

Herman Fritz

Architect Herman Fritz was actually born in Rutherford in 1865 and experienced the building trade first as a carpenter. When he set out to design his own structures, he opened an office in the prominent Passaic National Bank building in Passaic. His designs reflected a grander, more romantic feel that was evolving during the Queen Anne style of construction. Many of his turn-of-the-century designs are still extant in today's Rutherford. These structures include the Charles Lyon House (43 Donaldson Avenue), the Sidney Bell House (149 Ridge Road), the Isaac Lord House (70 Ridge Road), the Danheim-Willis House (now Temple Beth-El, at 185 Montross), the Methodist-Episcopal Church parsonage (60 West Passaic), the Jackson House (194 Montross), the Sandford House (268 Carmita) and the Charles E. Tolhurst House (30 West Passaic). He also created vernacular designs in Ridgewood, Tenafly, Hasbrouck Heights and Ridgefield Park.

A Thriving Business

Other pattern designers from outside the area, such as David S. Hopkins, would influence local builders. A stunning example of his design is extant at 219 Ridge Road. Using designs from Woodward, Hussey, Fritz and others, many builders thrived. Jacob Rohrbach was said to have built over one hundred houses in Rutherford, with one of the best extant at 172 Mountain Way. Rutherford builders, who included Bernard J. Schweitzer, A.P. Hackett, Harry C. Brouwer, John and Charles Dabinett, George M. Davenport,

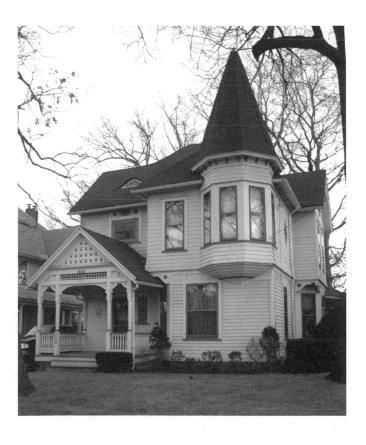

219 Ridge Road today.

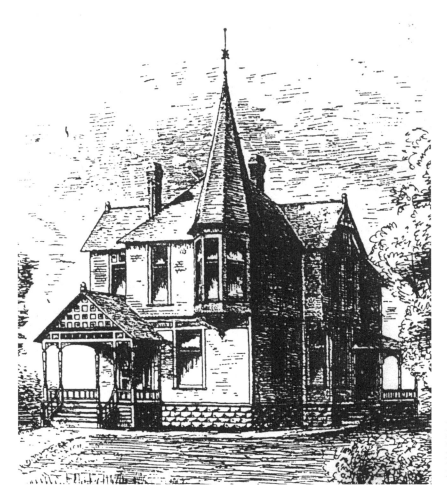

Plans for 219 Ridge Road, from David S. Hopkins's pattern book.

Charles C. Emerson, S.T. Galloway, Charles Howard, Julius Jaeger, Charles Plainer, Carl Schoneman and George W. Sturges Jr., all pushed the architectural landscape into the twentieth century.

Excellent furnishings and finishes were also well represented in the Rutherford area. A "Yates Casting" was nationally known for superior quality. Having come to Rutherford in 1867, Benjamin Yates engaged for a time in the manufacture of iron castings but then graduated into becoming a builder. After erecting about a dozen houses, he retired from business. His home is still extant as the wonderful Second Empire house on the hill at 124 Orient Way. Charles R. Soley was a building contractor who commenced a steam planing factory in Rutherford in 1890. It was the source for finely crafted windows and moldings. The factory was located near The Terrace on the slope of the former Mount Rutherford peak, and straddled Sylvan Avenue. Soley eventually became sheriff of Bergen County in 1901.

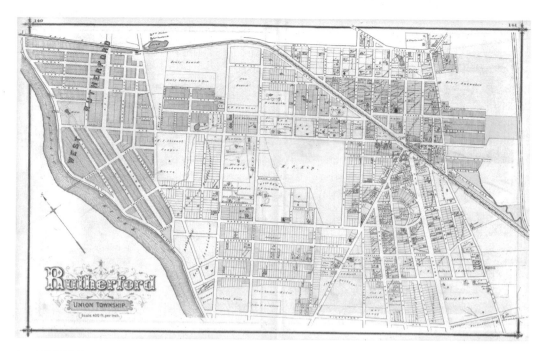

An 1876 Walker map of Rutherford.

Mapping a Town

The 1860 population of all of Union Township was 952. By 1885, the population of the Borough of Rutherford alone was 1,335. One of the area's, and county's, most important map sources was published in 1876. The Rutherford maps included in *Walker's Atlas of Bergen County* were detailed enough to show most of the known buildings and land plots labeled with the owners' names. It also recorded all of the real and proposed streets, as well as some land associations. The map revealed a maturing community with phenomenal growth.

Large residential estates were scattered throughout the town, yet the locus of the settlements was still on the east side (east of Montross) and close to the avenues of Park, Union, Newark and Erie to Orient Way. It would seem that the Mount Rutherford Company was ahead in the area's development race. If sidewalks existed, they were made of wood planking. Park Avenue had almost a dozen businesses, including Stewart's Hotel at Franklin Place.

Also depicted on the 1876 Walker Map was the area below Division (now Jackson) Avenue to the Passaic River, and from Erie Avenue across Union all the way south to the end of Passaic Avenue. It was known as West Rutherford, or on other maps, Santiago Park. Although proposed streets and land plots were drawn, it took another seventy years to actually fill out and populate. The area was still somewhat desolate and closer to what Waling Jacobs would remember than what we know today as the Memorial Field and Hastings part of town. There was a small depot at Erie Avenue across from Standard Bleachery. From there, the Erie Railroad Main Line crossed the river into

Acquackanonk, and as yet there was no Union Avenue Bridge. On the north side of Union Avenue was the magnificent Holsman Hotel, also known as the Santiago Park Hotel and West Rutherford Hotel. This was one of the handful of summer resort hotels established along the east bank of the Passaic River. For visitors, the resort sported a trout-stocked pond, ornamental fountains and a dock for arrival by boat. Namesake Daniel Holsman represented Bergen County in the New Jersey Senate from 1863 to 1865. Late in the nineteenth century, it became a private school for girls called the Rutherford Hall Institute. Disuse and abandonment allowed it to be destroyed by fire in 1903. Just across Union Avenue, and a few steps south of the hotel, were the remnants of Waling Jacobs Van Winkle's original homestead on the Passaic.

OF THE BIRTH OF A BOROUGH

First in Bergen County

In 1881, the independent character of Rutherford revealed itself and inspired thousands outside its borders. A century after the nation struck its independence, the example of a thriving Borough of Rutherford set off a revolution in municipal governance.

In 1881, less than twenty years after the Civil War, Rutherfordians petitioned for secession from Union Township. Local citizens sought more control and representation in their government. They were encouraged by the 1878 New Jersey legislation, "General Incorporation by Election Act," authored in part by Rutherford lawyer Luther Shafer, who can be rightly called the "Father of the Borough." Shafer was born in Montgomery, New York, in 1848 and graduated from the Albany Law School. In 1870, he moved to 105 Feronia Way (extant) and was admitted to the New Jersey State Bar in 1873. He became an expert in municipal law and was asked to take the position of township counsel of Union Township.

The General Incorporation by Election Act of April 5, 1878, enabled any township, or any part with a land area of not more than four square miles and with a population not exceeding five thousand, to establish itself as an independent "borough" (self-governing incorporated town) simply through a local petition and referendum process. Before 1880, the entire state of New Jersey contained fewer than twenty boroughs, and all were created only by special acts of the state legislature.

Many residents of the Rutherford area of Union Township were unhappy with their poor roads and uncertain economic conditions. Residents believed that their tax monies were financing outer areas of the township. Shafer was probably one who was disgruntled, primarily because, through his counsel, initial steps were made toward Rutherford's incorporation as a borough.

In June 1881, the Rutherford Improvement Association was formed to propagate the movement toward independence. During September, a public referendum was finally organized and held on the twentieth. It was reported that "there were 161 names on the poll list; ballots for incorporation numbered 91 for; against 70." The certificate

Luther Shafer, father of the borough form of government.

Luther Shafer's signature.

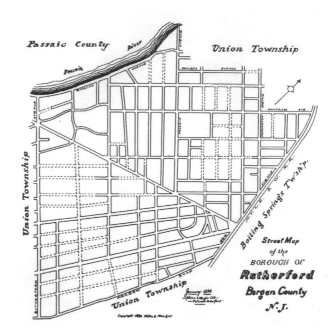

An 1881 map of the borough
of Rutherford, split off from
Union Township.

of election was filed in the Bergen County Clerk's Office on September 21, 1881. On October 4, Alfred Oakley was elected the borough's first mayor, along with six council members: Edwin C. Abbott, Robert Burgess, Abram Yereance, Kenneth K. King, Edwin LeClear and Edmund Wright. The next day, the first council meeting took place in the upper floor of Union Hall. "The Mayor and Council, Borough of Rutherford" (actual name) had become the first borough of Bergen County. The first ordinance was written November 21, 1881, stopping horse-drawn vehicles from driving over sidewalks.

Opposition to this secession was probably what dictated a border that was a bit saw-toothed. Some of the township's original farmers undoubtedly feared an increase in taxes for improvements that seemed to benefit commuters and the influx of outsiders, and this likely fueled their demand to be excluded from the new borough. The result was that Rutherford's perimeter was

> *from the center line of Meadow Road to the Erie Rail Road west to Beckwith's Bridge, south on Willow Street west to Washington Avenue, south through the Spiegel land through Union Avenue to Santiago Avenue to Passaic Avenue, west to the Passaic River and south to Rutherford Avenue*

and returning to the point of beginning. (Beckwith's Bridge is now the Montross Avenue Bridge, Willow is now Montross Avenue and, as previously mentioned, "the Spiegel land" is the area behind 300–326 Union Avenue.)

So perhaps there was not a great outburst of fanfare and rejoicing. Independence remained incomplete, as Rutherford still formed an integral part of Union Township.

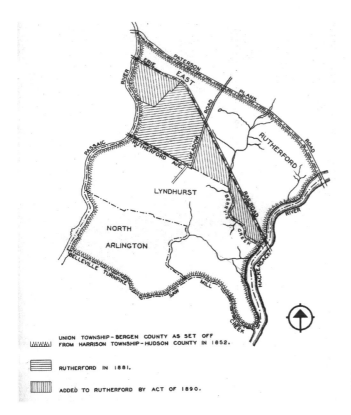

UNION TOWNSHIP - BERGEN COUNTY AS SET OFF
FROM HARRISON TOWNSHIP - HUDSON COUNTY IN 1852.

RUTHERFORD IN 1881.

ADDED TO RUTHERFORD BY ACT OF 1890.

An 1890 map of the borough of
Rutherford, indicating its original
1881 shape within the final borders.

All matters beyond simple local control continued to be decided by the township, which still controlled the tax assessor, tax collector and justice of the peace. But the die was cast and greater freedom beckoned. In January 1890, Hilton & Menger completed a survey and assessment map of the borough showing its boundaries as originally described. On March 10, 1890, an act passed by the senate and general assembly of New Jersey enlarged the boundaries of Rutherford to their present size and shape.

In 1894, with the success of the Borough of Rutherford as a good example, "boroughitis" struck all of Bergen County, as twenty-six "new" boroughs were rapidly carved out of the early townships. The formation of Bergen municipalities continued until 1924, when the number reached seventy. Today, Bergen County consists of three cities, two villages, nine townships and fifty-six boroughs.

For years, Luther Shafer consulted with many other municipalities regarding the possibility of becoming a borough. In March 1882, Luther Shafer became the mayor of Rutherford and then was repeatedly elected for three subsequent terms of one year each.

Up to this point, much of the history of Rutherford had been about the struggle to build a place. The early settlers, farmers and other residents had always worked the land to establish a secure and sustaining place for their families and friends. But more and more they worked to create the intricate social structures that would establish their town as a place to live and enjoy. Many of the one-time "outsiders" now found that their home was hard to leave.

OF A CIVIC CENTER

Service and Study, Play and Pleasure

The blossoming of Rutherford's rich civic life and the evolution of the face of the borough—its municipal buildings, schools, parks, theatres and monuments—have always gone hand in hand. Past and present, Rutherford's vision of its future and remembrance of its past have come together in a beautifully balanced coexistence.

OLD BOROUGH HALL

What is a town without a focal point for its civic participation? In Rutherford's early days, the private Union Hall on Ames Avenue hosted so many community functions that its location was unofficially noted on the 1890 Sanborn Fire Insurance Map as "Town Hall," but it was always too small and faced a side street. A larger, more centrally located, preferably Park Avenue address was needed. The first borough hall for Rutherford would be the result of the continual growth of Park Avenue commercial structures and the expanded space it afforded.

Mayor E.J. Turner's grocery store (extant at 88 Park Avenue) was built in 1895. It was a grand building almost in the center of the business district and away from the noisy train station. During the winter of 1896–97, it was paired to its south with the newly constructed Armory Building (92 Park Avenue) to become the home of Captain Addison Ely's National Guard, Company L, Second Regiment. The new Armory cost $20,000 and opened in March with the personal blessings of New Jersey Governor Griggs. It offered large public spaces and even a stage and bowling alley. Sometime after 1897, another building was added to the north at 82–84 Park Avenue. With this new construction, the Rutherford Post Office had finally found a place it could call home, at least for the next quarter century.

These three large brick and terra cotta façades were architecturally related in mass, style, exterior fabric, fenestration and decorative finish. Together, they expressed a unified central core in the growing downtown. The Rutherford Post Office was now the main postal hub for the South Bergen area, so it seemed logical that on April 3,

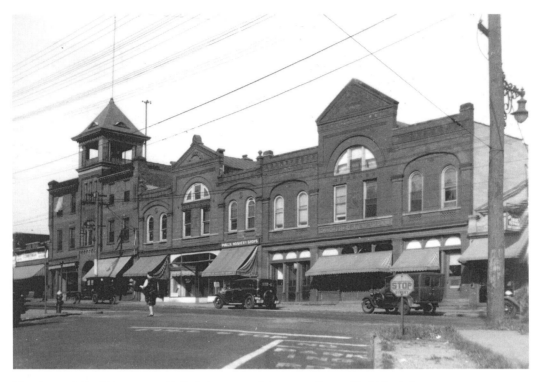

First Borough Hall/Armory at 92 Park Avenue and the post office at 82–84 Park Avenue.

1900, the armory was acquired for use as Rutherford's Borough Hall. It housed the tax assessor, collections, justice of the peace and police headquarters. A notable moment in Rutherford's history occurred on May 25, 1912, when President William Howard Taft addressed a crowd of more than ten thousand people in front of the old Borough Hall.

RUTHERFORD POLICE DEPARTMENT

A few years before the Borough of Rutherford broke away from Union Township, it was perceived that there was a vagrant problem due to the financial crisis of the mid-1870s and the proximity to New York City. Citizens moving out of the city sought more stringent protection of their lives and land. It was in June 1879 that residents A.P. Williams, John Borkel, George F. Schermerhorn, Jules Ducommun, Jonathan Kelshaw, George Hollister, S.W. Hollister and William Earle decided to organize the Rutherford Protective and Detective Association. This association sought to use "lawful means for the prevention of crime, the recovery of stolen property, the detection, arrest, prosecution and punishment of criminals and the maintenance of good order in the township of Union." The board of directors could deputize up to twenty of the association membership and designate a captain "to whom all orders were to be given, and through whom all reports were to be made." Guided by Civil War veteran Major Richard Allison, the association successfully kept order and was a driving force in the effort to separate Rutherford from Union Township.

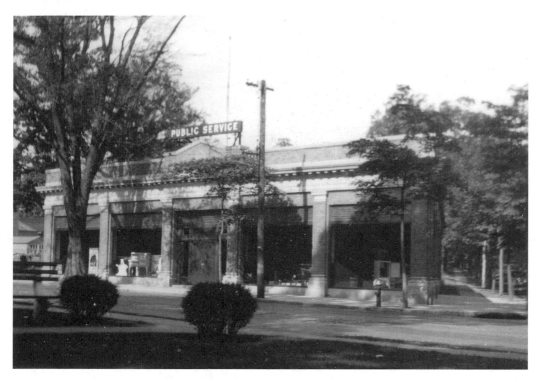

Rutherford Police Department headquarters, once a Public Service Electric and Gas building. *Courtesy of Edward Lise.*

RUTHERFORD FIRST AID, AMBULANCE CORPS

Four years after the end of World War II, a group of citizens formed to generate interest in a volunteer ambulance corps. The need was great, as local hospitals were discontinuing their own off-site emergency and transportation services. Thomas M. Crotzer, Roland D'Ablemont and C. Douglas Collyer realized the problem and sought support from the Rutherford fire companies, police and borough government. Eighteen members were recruited, and on August 24, 1950, the newly established ambulance corps transported its first patient to St. Mary's Hospital in Passaic. The ride was made in a brand-new Cadillac 8, Metro model outfitted by A.J. Miller. The corps was originally located in the old stable area in the rear of the Ames Avenue firehouse. The facility was completely replaced by a new building in 1982. On average, the volunteers promptly and professionally respond to over one thousand calls a year yet rely on contributions for almost all their operating revenue.

THE HACKENSACK WATER COMPANY

The Hackensack Water Company began to pump water to Rutherford in 1891. The company was originally chartered in 1869 as a public water system just for the village of Hackensack. It suffered through neglect, the 1873 panic and receivership until it was sold

to a new group of investors headed by Robert de Forest. Waterborne illness struck cities and suburbs alike just as northern New Jersey scientists stepped to the forefront of the water supply field. The new management moved the company to first deliver a steady supply of water and then to constantly improve on its quality for consumption.

THE RUTHERFORD FIRE DEPARTMENT

Rutherford's mayor and council approved a July 20, 1893 ordinance for the placement of up to fifty-five fire hydrants throughout the borough. By 1900, forty were in service. Before hydrants were common, fires were extremely devastating and, more often than not, could not be fought successfully. Large fires erupted all over Station Square and leveled most of the structures that surrounded it. In 1890, fires razed much of the western side from Union Avenue to Ames Avenue. The next year Dupuys, a two-story frame building at the corner of Ames, was destroyed. It was rebuilt as the Shafer Building (extant).

Another fire on December 8, 1895, burned down the original site of the Rutherford National Bank located close to the Van Winkle store. The fire was so hot and destructive that it took days for the bank safe to cool down.

The history of the Rutherford Fire Department begins with the May 12, 1876 organization of Company 1 as the Union Truck and Bucket Company. The first firehouse was located at Station Square. The first firefighting apparatus was a long wooden cart that held ladders and leather water buckets. This primitive fire "truck" was pulled through the unpaved streets of town by the firemen. At the time, firefighting was limited to placing a ladder against the burning building, mounting several firefighters on the ladder and passing up leather buckets filled with water. The top man would throw the water on the fire and drop the empty bucket to the

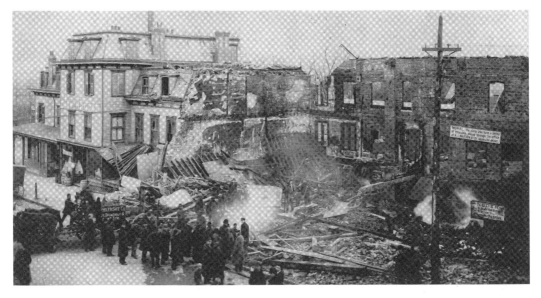

The McMain/Rutherford National Bank fire, December 8, 1895.

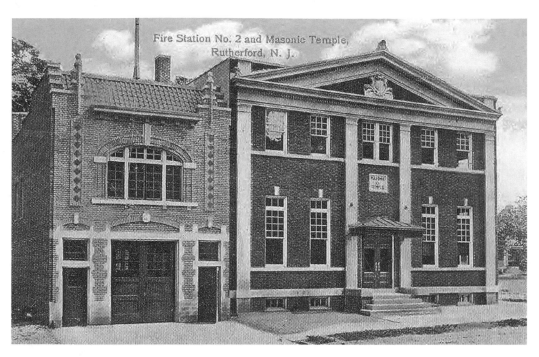

Firehouse 2 and Masonic Temple.

ground, where it would be refilled and sent back up the ladder. It took much courage and skill to work a fire, especially if you were the top man on a wooden ladder.

The first fire call that Company 1 responded to came on the morning of Sunday, July 8, 1877. A telegraphic message was received at the Rutherford depot that the assistance of the Rutherford Fire Company was needed at the train depot in neighboring Carlstadt. Fires were common near railroads and stations, as sparks from locomotives could ignite brush and wooden structures in seconds.

Company 1 moved into a firehouse near the present Ames Avenue location in 1910. The old Union Truck and Bucket Company firehouse has been preserved as the ATM office of Chase/Bank of New York/National Community Bank at 23 Ames Avenue.

Fire Engine Company 2 was conceived at an informal meeting on March 3, 1886, at the residence of Mr. John E. Pontin to formulate a meeting with Rutherford Mayor Luther Shafer to incorporate and name a new engine company. Several names were considered for the company. Rutherford Fire Engine Company 2 was placed in service on March 24, 1886. The first firehouse was the McMain Building, and the second was built in 1899 near the Baptist church on West Passaic Avenue. In 1913, the company moved to 167 Park Avenue (now Café Matisse) but left in 1972 for the current firehouse at 400 Mortimer Avenue. This building was the former DeMassi Cadillac showroom. This engine company was informally known as the "Top Hatters."

West End Engine and Hose Company 3 was organized on June 19, 1890. Its first firehouse was located at 323 Union Avenue (extant, but greatly changed). The house had an alarm bell that clanged to announce that a fire had started and to summon the firemen. In 1925, the company moved to its current home at the corner of Wells Place

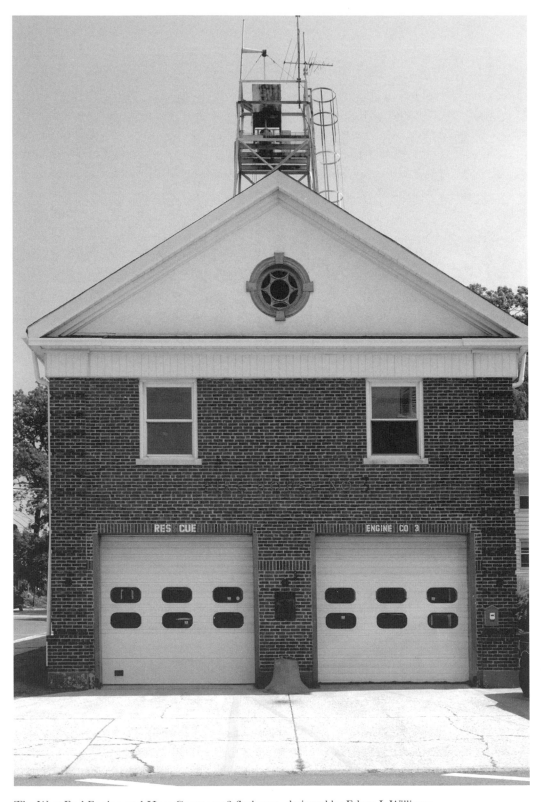

The West End Engine and Hose Company 3 firehouse, designed by Edgar I. Williams.

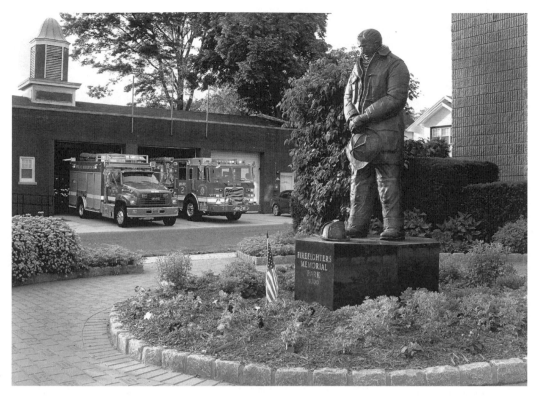

Fireman's Park and the Engine Company 2 firehouse today.

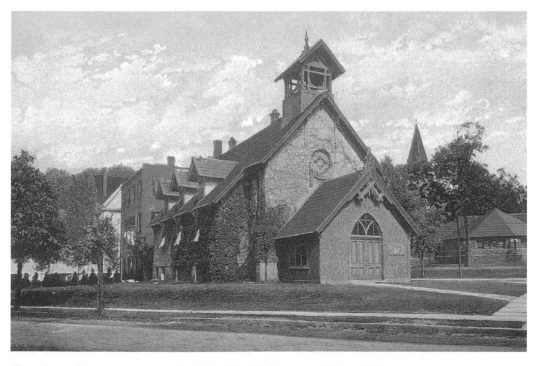

The original Presbyterian church, Rutherford Public Library and Ivison Hall.

and Union Avenue. The firehouse at 348 Union Avenue is the oldest continuously used firehouse in town and was designed by Rutherford architect Edgar I. Williams.

Rutherford Engine Company 4 was organized in 1896. Its original firehouse was located on Orient Way close to Glen Road, but in 1910 it moved and shared the Union Truck & Bucket Company 1 firehouse on Ames Avenue. Company 4 had the distinction of owning the first firefighting apparatus to be pulled by horses. On November 4, 1978, Companies 1 and 4 moved into a new firehouse at 40 Ames Avenue. It was located just across the street and next to the Elks Lodge, and it became the headquarters and communication center for the Rutherford Fire Department. Around the time of the company's organization, ten red fire alarm boxes were installed at strategic intersections throughout the borough. Each box was assigned a location number, and when activated the box would send a telegraphic signal to identify its number. The system was installed by W.H. Petty & Company and grew to twenty-four boxes within twenty years. The boxes were connected to outdoor warning bells in the bell towers around town and to gongs in the firehouses. This system has grown to sixty-six street alarms and is fully operational and very reliable today.

Rutherford Fire Rescue Company 5 was organized in 1948 as a civil defense and rescue squad. It shares the West End firehouse with West End Engine & Hose Company 3. If one looks at the rooftop of this firehouse, one of Rutherford's two remaining fifty-year-old diaphone alarm horns can be seen. The other is atop Borough Hall. Actuated fire boxes and, later, phoned-in alarms would translate to loud blasts on these horns to call the firemen to respond to a fire. In the 1980s, problems began to arise. False alarms and sticking air valves would result in long blasts, sometimes lasting for several minutes. In September 1994, the diaphones were disconnected from the street box circuits, and eventually they were completely turned off. Many old Rutherfordians still miss the sound of the fire horns and remember their nearest fire box numbers.

Firefighters' Memorial Park is opposite firehouse #2 in a small triangle on the corner of approximately 300 Park Avenue, West Pierrepont and Mortimer Avenues. This park honors firefighters Edwin L. Ward and Thomas Dunn and all the deceased members of the Rutherford Fire Department. The park is maintained by former Fire Chief Thomas Twist. The park was once called Firemen's Memorial Park and was originally located on the wooded hillside at the northeast corner of Sylvan Street and The Terrace. It was dedicated on December 16, 1959. The current park has a moving statue of a bowed firefighter in his turnout holding his helmet while looking down to the helmet of a fallen firefighter.

THE FREE PUBLIC LIBRARY OF RUTHERFORD

The Free Public Library of Rutherford was begun by the Women's Reading Club of Rutherford and incorporated January 4, 1894. On May 5, the library was opened in a second-floor room of the Shafer Building at Ames and Park Avenues. The first year it was established with a collection of 784 books and four hundred borrowers. As the larger church was being readied, David Ivison gave to the library association the corner property of the former Presbyterian parish at the intersection of Chestnut Street and

Park and Passaic Avenues. The first library moved into the downstairs of Ivison Hall in 1896 and then filled the upstairs in 1901. But it struggled financially. Entertainment programs were organized to bring in revenue. Generosity by the Fortnightly Club, the Town Improvement Association and the Women's Reading Club buoyed the library until it was taken under municipal control in 1908. Many of the early trustees included Charles A. Van Winkle, Edward J. Turner, Henry Bell, Elliot Hussey, William McKenzie and John Tyler.

By 1914, there were 2,177 borrowers sharing over seven thousand books. Many family legacies and donations brought in valuable collections of old and new volumes. During both World Wars, the library collected and shipped over fifteen thousand books to all branches of the armed services. The always-prominent Ivison Hall would be adapted over time until it had to be replaced by a more appropriate building in 1956.

RUTHERFORD SCHOOL SYSTEMS

The Early Schools

Rutherford's first two schools are believed to be established within the budding Dutch community on Newark Road (Meadow Road). According to Rutherford historian James Hands, the first school may have been erected as early as 1819 and a second one by 1852. Students attended by subscription and were schooled in one-room, one-story, wood-frame structures. By the late 1860s, obsolescence led to the abandonment of the Newark Road school. A new, more centrally located Park School (Donaldson and Park Avenues) was built and opened by 1870 at the cost of $11,000. It was two stories high, contained four classrooms and had a floor space of forty by fifty-two feet. Captain Addison Ely served as principal in 1879. The Park School capacity was doubled in 1880, when a back extension was added. Attendance was 154 students in 1883.

In 1889, another fine schoolhouse was built at the corner of Highland Cross and Sylvan Avenue. Sylvan School was intended for the primary grades and had four classrooms within a frame structure. The first Union School (Union and Springfield Avenues) was constructed in 1892, as a brick structure with five classrooms. District enrollment was up to five hundred students managed by twelve teachers and one principal. Some students were arriving from East Rutherford.

Twentieth-Century Public Schools: A Population and Building Boom

At the turn of the twentieth century, the borough decided to demolish the thirty-year-old Park School and replace it with a modern brick structure on the same site. The new school was designed by the Belleville, New Jersey architect Charles Granville Jones. Park School now contained fifteen classrooms, a five-hundred-person auditorium, a library, a gymnasium, offices for the board of education and a kindergarten. It opened in May 1901. High school was now a full four years. Union School received an addition in 1905, and the Pierrepont School, new in 1907, provided another eastside school for kindergarten to sixth grades. In line with the overall growth rate of the borough, the student population had doubled by 1912.

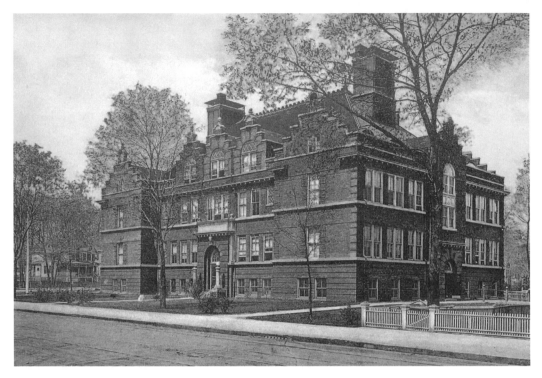

Park School, circa 1903.

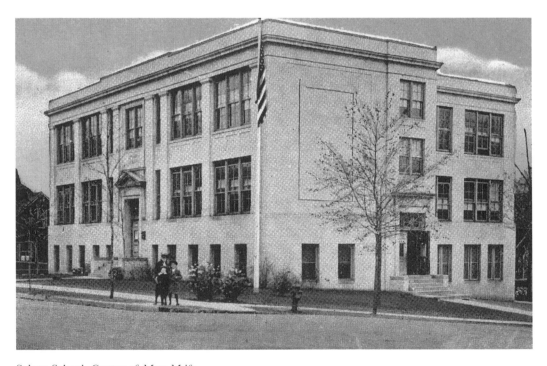

Sylvan School. *Courtesy of Mary Melfa.*

By 1913, two more schoolhouses were needed and constructed. Washington School, at Wood Street and Washington Avenue, and Lincoln School, on Montross and Vreeland Avenues, were almost identical in form. Each school held 250 students and primarily served the surrounding neighborhoods. The original Sylvan School suffered the same fate as the original wooden Park School when it was demolished in 1915 and replaced. It reopened in 1917 as a new brick-faced building with a basement that could be used as a gymnasium or assembly room. The capacity was 320 students.

The older part of the present Rutherford High School complex was built in 1921. The site chosen had been part of the shrinking Kip Farm. From Union Avenue, the new high school could be plainly seen just beyond Henry Kip's field. The school fronted onto Elliot Place and was constructed of light, buff-colored brick. The first class of 437 was welcomed in September 1922, and the newly dedicated four-year high school was in place for just a while. Overcrowding forced Rutherford to leave the eight-four system and adopt the six-three-three course (six years of grammar, three of junior and three of high school). In 1926, this seemed to work well and offered a smoother transition for students into high school. To facilitate this change, the old Union School was torn down and the new Union Junior High School was designed by Fort Lee school architect Ernest Sibley. Pierrepont School received an addition of seven classrooms in 1927.

Still, the school population grew. To make matters worse, the 1901 Park School was rapidly deteriorating, and overcrowding only hastened its demise. Park was being used as a junior high school, and parts of it were totally unusable. As that building closed for conversion into today's Borough Hall, a wing was added onto Pierrepont School to make it into a junior high school. More additions brought Rutherford High School up to standards for inclusion on the Middle States Association of Colleges' approved list. The school facilities remained essentially the same until 1957, when a junior high school was designed by architects Micklewright and Mountford and opened for use.

Rutherford has been blessed to have a complete parochial school system just around the corner from its public high school. Saint Mary Elementary School (72 Chestnut Street) grew out of the parish of the Church of Saint Mary (91 Home Avenue) and was promoted by its pastor, Father William F. Grady (1908–15). On September 27, 1916, the school opened with one hundred students. The first principal was Sister M. Loyola. Father James J. Smith succeeded Father Grady and donated to the elementary school a poignant statue of Christ embracing a small boy and girl. It is located at the top of the third-floor stairwell off the Chestnut Street entrance, and its inscription reads: "Learn of Me, for I am Meek and Humble of Heart."

St. Mary's High School

Affiliated with Rutherford's Church of Saint Mary, St. Mary's High School was established in September 1929. The Sisters of Saint Dominic of New Jersey provided the first course of instruction. The high school building was constructed in 1931 and opened on November 5, 1932. It was expanded in 1959. The Beaux Arts–style structure appears to form a *v* at the beveled apex of the Ames Avenue and Chestnut Street entrance. This entrance has four stone Corinthian columns and is topped by an eight-sided cupola on a square base. The school is governed by the Roman Catholic

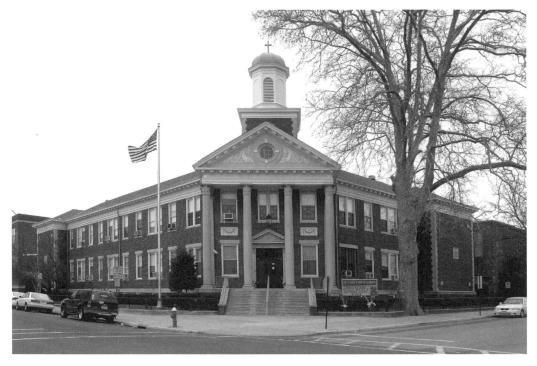

St. Mary's High School.

Archdiocese of Newark, and the St. Mary High School Gaels compete in the Bergen County Scholastic League.

THE NEW BOROUGH HALL: PARK SCHOOL TRANSFORMED

Louis B. Huesmann (1890–1952), of the local architectural firm Osborne and Huesmann, attended Columbia University and maintained an office at 13 Orient Way. Louis was asked to draw up plans for the conversion of the condemned (1937) Park Avenue School into Rutherford's second Borough Hall. Mr. Huesmann and his partner, John Osborne, were to design the new civic hall to house all the borough offices and to utilize as much as possible of the existing structure designed by Charles Granville Jones and built in 1901. Jones had designed an ornate, somewhat Gothic brick structure that could hold as many as five hundred students. This conversion, along with the new post office next door, was one of the 125,000 national projects assisted by the Federal Works Progress Administration (WPA) from 1935 to 1943.

Osborne and Huesmann stripped off the top story over the school gymnasium floor and eliminated its steep, fussy roofline and windows. Now the roof of Borough Hall would be more conservative and durable, and would feature a railed-in widow's walk at its center. The side wings and their entrances would stay somewhat the same but would reflect a more refined finish. The proportions were more pleasing, stately and befitting a progressive municipality's home. The important Park Avenue entrance lost

The front entrance to the Rutherford Borough Hall.

two massive balustrades and was lifted up by nine wide steps to a concrete podium. This front porch, nestled between the large side wings, was graciously framed with four two-story Corinthian columns and two matching side pilasters. The architrave above the columns modestly said all that was needed: "Borough of Rutherford." Huesmann's design surpassed the original in many ways, but it preserved just enough of the character of Charles Granville Jones's Park School. The building was proudly dedicated on July 4, 1939.

SHADE TREE COMMISSION

The Borough of Rutherford thought highly of its existing tree stock and the effect it had on the borough's quality of life. The mayor and council sought ways to increase the propagation and maintenance of its public trees. The first action was taken in 1897, when an ordinance was passed to provide for tree planting on newly graded streets. In 1908, the Shade Tree Commission was established and resulted in more massive replanting and landscaping of the now-settled streets of Rutherford. So many of the fine sycamores, maples, lindens and oaks that populate our avenues and parks today are the result of this commission's work. Amidst growing legal concerns, many towns, including Rutherford, abandoned their standing tree committees in the early 1990s. But recently, this commission was revived and is determined to reforest the public landscape.

RUTHERFORD PARKS

Lincoln Park is a beautiful complement to Rutherford's busy Borough Hall. Before the park's inception, its area encompassed residential properties owned by Mrs. Minnie Hooper and Dr. J. Farrington within the triangle formed by Chestnut (now Lincoln) and Park Avenues and Highland Cross. These properties faced the new Park School erected in 1901. The Rutherford Town Improvement Association (TIA), an active offshoot of Margaret Riggs's Woman's Reading Club, leased the two properties in 1903. The association promoted a progressive course of enlightenment and beautification that included the establishment of parks and a town square. A year later, the borough enacted an ordinance to purchase the land for "the free use of the citizens and residents of the Borough of Rutherford, forever." A bond issue was created for the financing of the park's cost of $12,500 and was awarded to the Rutherford National Bank.

Hard work was ahead, as there were many trees and much undergrowth to be removed. The Bobbink and Atkins nursery donated trees and thousands of daffodil bulbs. The TIA provided a bench for trolley commuters traveling between Newark and Hackensack (Newark & Hackensack Traction Company). The new, triangular "town square" was named Farrington Park after one of its previous two owners; however, the identity of the park almost immediately became a matter of contention.

Two local veterans' organizations became involved, and a compromise—by the Civil War veterans' Gershom Mott Post of the Grand Army of the Republic (GAR) and the United Spanish-American War veterans' John T. Hilton Camp #3 USWV—was reached, resulting in the renaming of the park "Lincoln Park." Their conflict had originated when the "Gettysburg Stone," containing a plaque on which Abraham Lincoln's famous Gettysburg Address is inscribed, was moved from the prominent apex of the park, near Chestnut and Park Avenues, to a spot facing Park Avenue and the current Borough Hall in order to provide a place for the Rodman Cannon brought from Fort Schuyler (Long Island, New York) by the Spanish-American War veterans. The Gettysburg Stone remained in its less prominent location, but the park and the southern continuation of Chestnut Street bordering it were both renamed for the venerated president.

In 1907, the Cannon was rededicated to the soldiers and sailors of the Civil War and the veterans of the Spanish-American War. In 1914, one of the nation's many memorials to the servicemen killed on the USS *Maine* was placed in the park. It bears a tablet cast from metal recovered from the ship, which was destroyed in Havana Harbor on February 15, 1898. Part of the inscription reads: "Erected by the school children and citizens of Rutherford under the auspices of John T. Hilton Camp No. 3 U.S.W.V. May 30th 1914."

Another park was established in 1905, when Henry R. Jackson gave the town the deeply sloped land between Washington, Division (now Jackson), Raymond and Union Avenues. It was to be called Sunset Memorial Park. Mr. Jackson's estate was diagonal to this property, where the present retail strip of Jackson Village is now located. After World War I, a plan was conceived to plant a surrounding ring of Chinese elm trees near the curb. At the base of select trees, a simple brass and concrete commemorative plaque would forever be emblazoned with a soldier's name from World War I.

The Sunset Memorial Park commemorative for World War I soldier Addison Ely Jr.

The beautiful park on Riverside Avenue at the foot of Pierrepont Avenue is Van Winkle Park. It was dedicated in 1931 and has the names of the benefactors Winant, Charles, Stirling and Theodore Van Winkle on a central stone near the street. The four brothers were sons of Arthur Ward ("A.W.") Van Winkle and were relatively young men when the dedication took place. The park also contains one of the many Washington bicentennial commemoratives that were placed in Rutherford during George Washington's 200th birth-year anniversary (1932). This commemorative is a tree planting marked by a stone and bronze plaque near the waterside. Other Washington bicentennial markers are scattered throughout the town, including two in Lincoln Park, one at St. Mary's High School and a large plaque on the corner of the Rutherford Public Library.

RECREATION AREAS

Rutherford is fortunate to have three athletic recreation areas. Harold Wall Field lies at the intersection of Meadow Road, Eastern Way and Highland Cross and once held a grand estate. The original Tamblyn Field was once located at Hobart and Vanderburg Avenues and was named after Gerald (Jerry) Tamblyn, who was active in the early Rutherford Recreation Commission of the 1920s. Today's Tamblyn Field, on Woodland Avenue, was initially known as Rutherford Field and was the main recreation area for the town. It featured a wonderful baseball park with grandstands and a top-notch track. Rutherford Field was rechristened Tamblyn Field when the original (Hobart and Vanderburg) was turned into residential property.

The plaque at Memorial Field for J. Edward Tryon, Rutherford coach for five New Jersey State Championship football teams.

Rutherford Memorial Park is the largest recreation area. Once the location of veterans' housing, its thirty-acre parcel is the terminus of Monona, Darwin and Washington Avenues. It is in the very northwest corner of town along the Passaic River. Before World War II, the area below Jackson from the railroad to West Passaic was sparsely populated and underdeveloped. Part of this area south of Union Avenue was planned to be reserved for a recreational site, while the Memorial Field area was readied for residential development. In 1951, Rutherford voters decided to set aside the present area as parkland instead.

Tennis was a popular recreation and was adopted early (1914) at Rutherford High School as a competitive sport. Many public and private tennis courts were established throughout the town. The Rutherford Lawn Tennis Club had its own grounds and clubhouse on Montross Avenue (between Donaldson and Woodward Avenues), and the Pierrepont Tennis Club held court on Lincoln Avenue in 1924. Courts were also set aside at the corner of Beach and Union, on the Holman property on Lincoln Avenue and behind the Dannheim home at 185 Montross.

Recreation on the Passaic River

A strong interest in active recreational use of the Passaic increased at the turn of the twentieth century. New watercraft technology, combined with an appreciation for fitness, now competed with supply boats and barges. The Rutherford Canoe Club was located at the foot of West Newell and opened for pleasure boating in November 1894. The Rutherford Yacht Club was established in 1927. Rutherfurd Heights Association master carpenter Clarence Hardin contributed property and supervised construction of a new Yacht Club boathouse in 1928. He became its first commodore and presided over the opening races in June. On the Hackensack River in Carlstadt, the Rutherford Boat Club was opened on June 22, 1907.

ENTERTAINMENT VENUES: THE RIVOLI AND THE WILLIAMS CENTER

The William Carlos Williams Center was reconfigured from an old vaudeville theatre that was the famous entertainment venue known as the Rivoli. The Rivoli was built above the filled-in Glen Waters pond and opened April 21, 1922, as a "legitimate" theatre. It was a major stop on Tri-State tours for many entertainment greats, including Abbott and Costello and the Glenn Miller Orchestra. The Rivoli soon became a silent film theatre, complete with a Grand Wurlitzer pipe organ, before introducing the "talkies." In the 1950s and '60s, the Rivoli was a palatial movie house with a massive chandelier, whose twin was in New York's Roxy Theatre. In 1977, the front entrance and lobby were

The Criterion Theatre on Ames Avenue. *Courtesy of Virgina Marass.*

ravaged by fire. A year later, a group of philanthropists (led by Fairleigh Dickinson, Peter and Sally Sammartino and Oscar Schwidetzky, inventor of the ACE bandage) began the Williams Center Project. The new building opened in 1982 as a performing and visual arts center named in honor of poet and Rutherford doctor William Carlos Williams. Rutherford also had an earlier theatre located on Ames Avenue known as the Criterion. It opened on January 27, 1912. It was wildly popular, but a 1943 fire led to its closure.

WHY A DRY TOWN?

The origins of the continual temperance movement against serving alcohol in public venues are unclear. In the 1900 edition of J.M. Van Valen's *History of Bergen County New Jersey*, it is stated that regarding Rutherford "the sale of intoxicating drinks as a beverage has never yet been authorized." Rutherford historian James Hands believes that "Rutherford was a dry town largely because of the Women's Christian Temperance Union…who spoke to all the school children every semester on the evils of cigarettes and whiskey."

Chapter 8

OF A COMMUNITY

Churches, Clubs and Communication

From the birth of the borough, Rutherford has always valued and enjoyed coming together to share, serve, commune and worship. Through faith and fellowship; through organizations formed to entertain, enlighten or benefit others; and through the sharing of information throughout its long newspaper history, the people of Rutherford have provided a shining example.

EARLY RUTHERFORD CHURCHES OF THE NINETEENTH AND TWENTIETH CENTURIES

It is evident that the first settlers and landholders in the Rutherford area were almost exclusively Dutch farmers. Even into the middle of the nineteenth century, the area was sparse in population. The frugal Dutch did not see the need to establish a local church when they could travel a few miles for worship at the Acquackanonk, Hackensack or Second River Reformed Churches. As the railroad began to deliver different nationalities and religions, the local faithful sought closer buildings where they could gather for worship.

We can look back to Floyd Tomkins to develop an idea of how the early Rutherford churches began. In *Things Old and New from Rutherford*, he wrote:

> *We, my family and I drove to Bellville to church. In 1859 we started a "Union Sunday School," and I was made superintendent and some of my children were made teachers… The Sunday School was very successful; I kept it up for ten years. The Presbyterians came in and I helped them, the Methodists ditto.*

Presbyterian Church

Probably the earliest established Rutherford congregation was the Presbyterian Church. In the spring of 1863, during one of the hardest years of the Civil War, a petition was

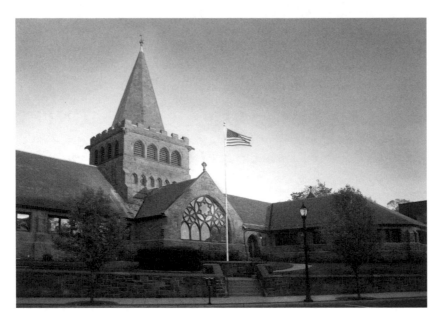

The Presbyterian church.

presented to the Presbytery of Jersey City to establish a congregation. Fifteen residents of the village of Boiling Spring, including David Ivison, William Crane and Daniel Van Winkle, sought to establish a local church. After receiving the presbytery's designation, they first met in Union Hall when it was still atop a small hill west of Station Square. The congregation grew rapidly and overfilled the hall. The founders sought to erect a more appropriate structure and received a plot of land from David Ivison at the northwest corner of Park Avenue and Chestnut Street. In the middle of 1869, a cornerstone was laid for the first church. It was a beautifully prominent brownstone built in a humble Gothic style. The structure fit its triangular site perfectly, but it quickly became too small a building to house the growing congregation.

Construction began in 1888 on the larger triangular site just across the street. The land was obtained from the Doremus family and contained large chestnut and oak trees. Described in the 1981 Bergen County Historic Site Survey as "Neo-Gothic rural English" style, this new church was a bit more inspiring than its older sister, and it was a lot bigger, as well. Stretching 189 feet long and 131 feet wide, it covered an acre of land. When it was finished on March 27, 1890, this church became the grandest structure on Park Avenue.

Grace Episcopal Church

On October 9, 1873, Reverend Elliot D. Tomkins, of St. James Church, Long Branch, led the celebration of the opening of Grace Church on West Passaic Avenue. Elliot was the son of Floyd Tomkins, who hosted the first business meeting in his (and Elliot's) Hill Home, which was just a hundred yards away. The history of the church began around 1867, when families, tired of driving to Christ Church in Belleville, decided to instead meet at the Rutherfurd Park Hotel on River Road (the old Rutherfurd family mansion). On March 4, 1869, the formal idea of a parish was developed. A committee, consisting

of Floyd Tomkins, George E. Woodward and William Ogden, was appointed to discover how land and construction could be found for a church building. During this time, the congregation met at the hotel and then Union Hall on Ames Avenue. In time, Tomkins would donate land close to Hill Home, and financing was obtained to build an uncoursed brownstone structure in the style of English Gothic. The stone would be obtained from the Belleville quarries.

The cornerstone was laid at 128 Passaic in October 1872. In 1890, a new transept and chancel were designed and added by church architect William Halsey Wood. One of the most prominent features is the front crenellated tower. A great bell, weighing 1,521 pounds, was installed. In 1911, a parish house was added facing Wood Street.

First Baptist Church of Rutherfurd

The First Baptist Church of Rutherfurd was organized on October 1, 1869, and was attended by eighteen interested members. Previously, the Baptist faithful had been meeting at the Union Sunday School at Union Hall and at the home of Benjamin Yates. It was decided that a building should be erected at the corner of Highland Cross and Park Avenue. Land was donated by Deacon Richard Shugg, and the construction cost was $2,700. Many of the town's builders and architects were members of the church, such as Yates, E.C. Hussey and Samuel Hinks. We can now only imagine how wonderful this building may have been, as it was demolished for residential housing. Only fifteen years after its founding, the church met financial hardship and voted to disband. For a brief time, an entity called the Pilgrim Baptist Church held the interests of the congregation. This church was reorganized into the Rutherford Baptist Church in November 1887 and met in the Masonic Hall for a time. Again, the Shugg family was at the forefront of the establishment. Fortified by the congregation's growth, a new church was erected at 23 West Passaic and opened for service on January 26, 1890.

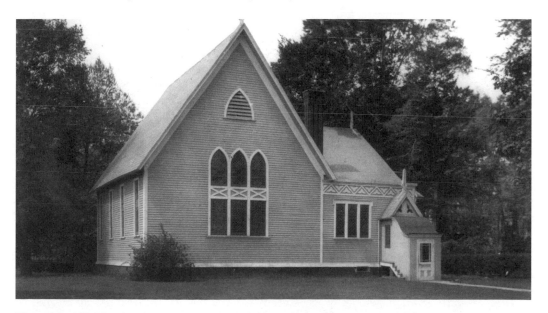

The original Baptist church, now hidden behind the modern edifice.

The Methodist Church of Rutherford

Beginning in 1869, two Methodist ministers from Passaic began to form a congregation in Rutherford. The Reverends A. Craig and E.V. King gathered with others in Rutherford homes to explain the Methodist faith. On December 15, 1870, they formally organized as the Park Methodist Episcopal Church of Rutherford Park. As with so many of the Rutherford churches, the congregation found a home with Union Sunday School in Union Hall. Some histories suggest that the church met with a financial crisis in 1878 and disbanded. The church reorganized as Rutherford Methodist Episcopal Church on March 3, 1880, with twenty members. The area nearby Union Hall must have been appealing, as a building site for a church was obtained from Mrs. Mary E. Ames and a small church was dedicated on November 20, 1881. The trials of this struggling congregation were not over—the new building proved to be inadequate. For sixteen years, the congregation moved around the community seeking a home. It first returned to Union Hall and then, later, worship was held at the site of the original Presbyterian church at Chestnut and Park. Finally, a building lot was secured just down the street from Grace Episcopal Church at 56 West Passaic Avenue. A cornerstone was laid and dedicated on April 12, 1896.

Unitarian Church

The Unitarian Church began in the parlor of George Bell's home on the same block where the present Congregational church stands. The Bell family owned the fine property on a rise that fronted on Union Avenue between Carmita and Montross Avenues. They

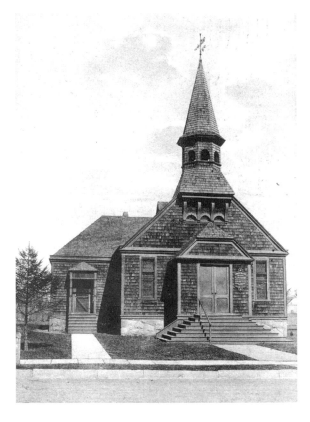

The Unitarian church.

hosted a group of residents who sought a more open form of Christianity. Twenty-two people founded the Unitarian Society of Rutherford on December 22, 1891. These included members of the Luce, Burrows, Beaumont and Danheim families. The Williams family, including William Carlos and Edgar Irving, and their father and mother, were very active in the congregation. For the first year, much of the worship was held in Union Hall and other locations. In 1892, the congregation looked to Mr. Bell for a plot of land, at 70 Home Avenue, on which to build a church. The construction was completed by December 15, and the church was dedicated as "the Church of Our Father." Reverend George H. Badger was the first pastor.

Congregational Church

This resilient congregation began as a branch of the Rutherford Presbyterian Church. Reverend Dana Walcott retired from the Presbyterian pulpit in 1878 and collected eleven former members to form an association called the Congregational Church of Rutherford. The first meetings were held at a small brick building at the corner of Park Avenue and Franklin Place, and the faithful also utilized Rutherford homes. By 1896, members of the Hollister and Bookstaver families started to plan for a new church and Sunday school in the West End. A lot was secured from H.G. Bell at 134 Belford Avenue (extant), close to Union Avenue. A cornerstone was laid on December 19, 1897, for the Emmanuel Chapel Society of the First Presbyterian Church. In 1907, the church became fully affiliated with the Congregational Church.

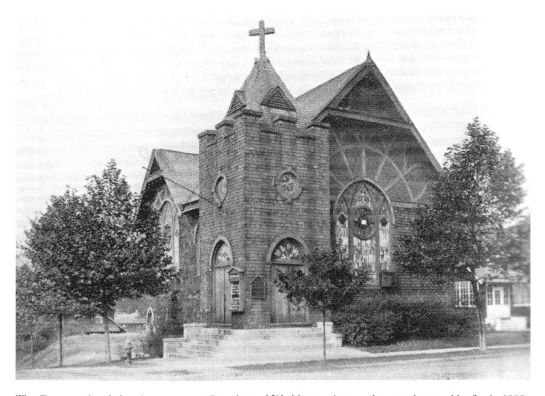

The Congregational church was once at Carmita and Washington Avenues but was destroyed by fire in 1923.

The church was growing with the town, and it decided to sell the chapel to build a larger home at the northwest corner of Washington and Carmita Avenues. By 1911, the new church was opened. Sadly, on the cold morning of February 15, 1923, a fire totally destroyed the new structure. It was a hard time for the congregation, as they had just lost their pastor, Henry Prentiss. The next year, Reverend Norman Pendleton took over, and the congregation was able to obtain a building lot that once had been the site of the Bell family estate and the first meeting place of the Unitarian Church. The architect Dudley S. Van Antwerp was commissioned to construct a new parish hall. It was funded by the family of James McKenzie, a member of the founding family of Standard Bleachery. The church at 251 Union Avenue was dedicated on October 26, 1924.

Mount Ararat Baptist Church

Organized in July 1896, the Mount Ararat Baptist Church began worship in Union Hall and later worshipped at the original First Baptist Hall at Highland Cross and Park Avenue. By 1902, plans were underway for a small church building on Elm Street. It was dedicated February 20, 1903. In 1919, the church that is present today was erected.

So it was that these early churches all had their origins in the early establishment of the Union Sunday School and the use of Union Hall on Ames Avenue. This important building, coupled with the generosity of Rutherford's prominent citizens, brought so many faiths together for so many times under one roof. This simple, but historically important, building would later be called the Ames Opera Hall.

Mount Ararat Baptist Church.

EVERYMAN'S BIBLE CLASS

This important lay organization was formed in 1922 through the men's club of the Rutherford Baptist Church and was initially led by the church's pastor, Reverend Lester H. Clee. It was not connected to any specific church, but rather to all churches. Part Bible-study group, part social organization and part service organization, its motto was "Serving men to get men to serve." The group elected "class leaders" and formed into red, white or blue "armies," conferring military ranking upon its leading members. Community service was always stressed, but there were many social, recreational and entertainment outlets in which the men could participate. A grand turnout of 266 men attended the first meeting on October 8. Within five years, the Presbyterian minister, Reverend Charles Rose, had joined with his Ivison Men's Club.

Everyman's Bible Class soon grew to be the largest fraternal Christian organization in the borough, with a membership of seven hundred and a weekly publication called the *Everyman's News*. It found a home at 34 Franklin Place in the old Rutherford Field House/ Union Club (97 Chestnut), but it would need the high school auditorium and Masonic Temple (extant at 169 Park Avenue) for many functions. Active for over seventy-five years, it was one of the most vibrant organizations in the borough's history.

EARLY SOCIAL ORGANIZATIONS

At the turn of the century, Rutherford was becoming a very social and civically active community. Published in Van Valens's *1900 History of Bergen County* is a list of clubs that were well established in the borough. They include Rutherford Council, No. 1229 of the Royal Arcanum, instituted January 17, 1890; the Boiling Spring Lodge of Free and Accepted Masons, chartered December 9, 1881; the Rutherford Lodge, No. 240 of the Independent Order of Odd Fellows (IOOF), instituted October 17, 1893; the Rutherford Lodge, No. 150, Knights of Pythias, organized September 16, 1893; the Knights of Columbus; and Rutherford Lodge 547, Benevolent and Protective Order of Elks (BPOE), which dedicated its beautiful building at 48 Ames Avenue on the anniversary of George Washington's birthday, February 22, 1908.

Into the new century, Rutherford's population grew, and so did the interests of its citizens as more social organizations were added. On February 25, 1912, an initial meeting convened to form a YMCA. The Rutherford chapter of the American Red Cross was founded May 22, 1916. Rutherford's interesting Polytopic Club had its first dialogue on October 28, 1916. The Lion's Club was dedicated March 8, 1922, the Rutherford Rotary Club was charted on March 28, 1922, and Rutherford's Kiwanis Club wrote its charter, effective July 27, 1925. The Rutherford Garden Club was established in the early part of the twentieth century in a town known for its exceptional gardens. By 1922, the club had given a large collection of garden books and provided the exterior plantings surrounding the original library building. The Rutherford Chamber of Commerce was incorporated in 1927 for the purpose of "promoting commercial, retail, industrial and civic activities for the economic and community development of the Rutherford Community."

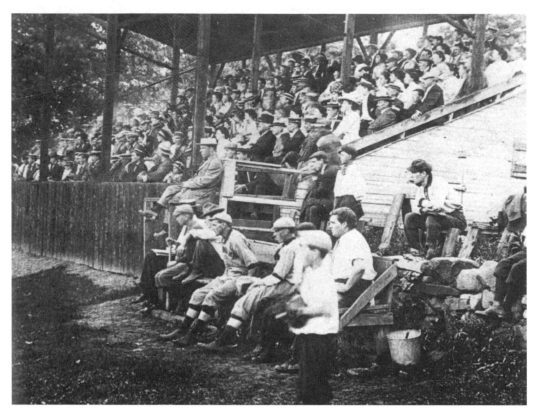

The baseball stands at Rutherford Athletic Field House, near Franklin Avenue. *Courtesy of Edward Lise.*

Rutherford Boy Scout troops visit the U.S. capital. *Courtesy of Wade Mahan.*

Rutherford Field Club

The Rutherford Field Club owned the building on the corner of Franklin Place and Chestnut Street (extant at 97 Chestnut). The Italianate building was constructed between 1867 and 1876 and had an athletic field and track adjacent to it. The Field Club offered many athletic activities but was reorganized by combining the Rutherford Wheelmen (established 1885) and the Rutherford Chess Club. On March 1, 1892, all of the clubs were reformed as the Union Club, which then moved to a beautiful building at 136 Park Avenue just across the street from the Presbyterian church. The grand opening of the club took place on October 26. The next year, it had members numbering over sixty. The objective of the club was to encourage social interaction among its members and their families through stage productions, billiard and bowling contests, dances, formal receptions and card parties. The charter of the club prohibited "the sale or use of intoxicating liquors in the club house, and by the rules and regulations of the club no gambling is allowed." For a time in the 1930s, the club would occupy Iviswold, but the club eventually dissolved by mid-century.

Boy Scouts and Girl Scouts

The first Rutherford Girl Scout leaders of troop 1 in Rutherford were Isabel Doyle and Jessie McLees. In February 1925, thirty-five girls met, and troop 2 was established soon after. The first Brownie troop was started in 1932. It met in the Sylvan School and Congregational church. The first Rutherford Boy Scout troop was formed in 1919 with Scoutmasters H.J. Vandermark and J.E. Selick. Camp Tamarack, a 240-acre scouting area on Skyline Drive in Oakland, was purchased by the South Bergen Boy Scout Association. It was opened in 1927. The Tamarack Council was formed in 1935 and had headquarters located on Donaldson Avenue next to Rutherford Borough Hall. In 1986, Tantaqua District (Northern New Jersey Council, Boy Scouts of America) absorbed Tamarack Council, and in 1996 the camp lands were ceded to Bergen County.

Women's Clubs

Rutherford had abundant male leadership, but it was not lacking in exemplary women's groups. The author of the first borough history, *Things Old and New from Rutherford*, was also a community organizer. Margaret G. Riggs believed that a mutual improvement association for women was needed. Her singular vision would evolve into several organizations that helped transform the borough.

In 1889, Margaret Riggs organized the Rutherford Women's Reading Club, offering her beautiful home at 47 Ridge Road (extant) as a meeting place for reading, discussion and enlightenment. Membership was open and grew so much that the club transferred its meetings to the parlors of the Rutherford Field Club and eventually moved to Park Avenue. Throughout its early history, the club's members amassed books and funds to equip the permanent collection of a lending library. In 1893, the subject of a free borough library was successfully debated by Mrs. Henry G. Bell. Following this, the club arranged to open the first Rutherford library in a room in the Shafer Building, at the corner of Ames and Park Avenues. By 1896, the old Presbyterian church, just next door to the club's meeting place (Union Club on Park Avenue), was being vacated and transformed

A Woman's Club illustration for the 1955 yearbook. *Courtesy of Helen Matthies.*

into Ivison Hall. The club's dream of a true town library was finally realized when the Ivison property gave the use of the building to the library, which initially moved into the basement.

Members of the Women's Reading Club organized into the Rutherford Woman's Club and were able to purchase the grand Ivison coach house at Fairview and Montross in 1924. The woman's club held the first meeting in its renovated home on February 1, 1926.

RUTHERFORD NEWSPAPERS

Regarding the importance of early Rutherford newspapers, architect E.C. Hussey wrote, in *Transcontinental View*:

> *Wherever there is found a sprightly, well patronized newspaper, it is good evidence of more than average intelligence on the part of the people. Rutherford enjoys the presence in its midst of a weekly newspaper, of medium size, known as "The Bergen County Herald."*

The *Bergen County Herald* was first issued in 1871, founded and managed by Henry Gerercke, a real estate dealer in Carlstadt. It reported primarily on the interests of the various land associations in the area. In 1873, it was purchased by Henry Kip, Charles H. Voohris and Jacob Westervelt. It had a strong political policy favoring the Republican Party. In 1875, the paper was sold to Rutherfordians John Haywood and James N. Bookstaver. Haywood managed the paper until 1883, when his health began to fail. Bookstaver stayed in the background, as he worked as the treasurer for Horace Greeley's *New York Tribune*. He eventually took the paper under his control until he disposed of it in 1885. At that point, the paper passed into the control of Nelson W. Young, along with Frederick and Nelson W. Wilson. Nelson Young was a newspaper man employed

The *Bergen County Herald*, volume 1, issue 2.

by the *New York Herald* and a labor advocate. Previously, he had been elected to be the 1870 coroner of New York. In 1876, he removed to Rutherford to a beautiful home at 92 Mountain Way (extant). The *Bergen County Herald* began as a Rutherford weekly and, in 1895, changed briefly to a daily afternoon paper. It returned as a Democratic weekly when Captain Addison Ely bought it and eventually moved it to Hackensack in 1897. In 1920, it became the *Evening Record and Bergen County Herald* and later just the *Bergen Evening Record*. It is now known simply as the *Record*.

When the *Herald* was sold to Nelson Young, James Bookstaver lost no time and created another local newspaper called the *Rutherford News*, published on every Saturday. The April 17, 1886 premiere issue had four pages, was twenty-two by fifteen inches and ran six columns to a page. The price was three cents, or a year's subscription for $1.50. Its masthead names were "J.N. Bookstaver, Editor and Proprietor, and Wilkin Bookstaver, Associate Editor."

The *Rutherford News* remained Republican in politics until June 1888, when it passed into new ownership. Over the next few years, the politics would change back and forth with a progressively independent view toward Rutherford's development. The paper was a strong advocate of good roads and a modern sewer system. The *Rutherford News* was eventually purchased by John Ketchum and, for a time, had Alexander R. Webb as an editor. Webb was an experienced newspaperman who was also a devoted Muslim, having converted from his childhood religion of Presbyterianism. He was one of the earliest and most important converts to Islam in the United States. He opened the first mosque in New York City and spoke extensively about his religion. He moved to Rutherford in 1898 and became very active in the community through the board of education. He died in 1917 and was interred in Hillside Cemetery. By 1900, the *Rutherford News* folded into the ownership of the *Bergen County Herald* and finally moved out of Rutherford and up to Hackensack for good.

John E. Tyler was a man with a vision. *The Bee* was a tiny, four-inch-tall news publication printed in Rutherford in 1882. It did not last long, but Tyler returned ten years later to publish the *Rutherford American* beginning June 30, 1892. He called it "a Live Local Newspaper." It started out as a weekly four-page, six-column newspaper published every Thursday. At twenty by sixteen inches, it was substantially larger than Mr. Tyler's first project. The paper would dominate Rutherford weekly reading for over ten years, until another newspaper arrived.

On December 29, 1904, it was announced that a new weekly would commence in April as the *Rutherford Republican*. Frank P. Newman was editor and the newspaper was produced by the Rutherford Publishing Company. It would be printed and composed first at the McMain Building and then at the Ketchum Building (the old Rutherford News building) at 3 Erie Avenue. The new weekly had only four twenty-four- by seventeen-inch pages, but it spread seven columns to the page. The subscription was a dollar a year, or three cents a copy. Within five years, John Tyler would sell the *Rutherford American* to Newman with the explanation that "a change of occupation and climate is necessary."

Newman combined the best features of the two papers into one in the *Rutherford Republican and Rutherford American*. The first issue came out on February 27, 1915, and it expanded to twelve pages in two sections, but then it retracted to an eight-page format. It was published each Saturday, and by 1919 it still cost $1.50 per year, or three cents a copy.

"Rutherford American" was eventually dropped from the title. The *Rutherford Republican* was published until 1952, when it was bought out by John "Jack" Thomas Wilson Sr. and eventually run by him and his son, who was known locally as Jack Wilson. On April 2, 1953, the *Rutherford Republican* was merged with the *East Rutherford Enterprise* and renamed the *South Bergen News* with an initial paid subscription of fifty-four hundred readers. Its offices were located at 38 Ames next to the Companies 1 and 4 firehouse and ambulance corps building. It was the official newspaper of Rutherford for public noticing of ordinances and announcements. The *South Bergen News* became the *News Leader* when the Savino family of Lyndhurst took it over after the death of Jack Wilson Jr. Counting all of the ownership and name changes, the present *News Leader* has a long editorial lineage that stretches back over 116 years.

Another weekly paper was established when the *South Bergenite* was first distributed on August 5, 1970, by veteran newspaper publisher Leo Ritt. Published every Wednesday from offices at 10 Ames Avenue, the newspaper began as a basic tabloid at eleven by seventeen inches. At the start, it was considered a "Shopper's Paper" as it had a high ad-to-news ratio. Although it had a stated cover price of ten cents, most people received it free when it was delivered to their front lawns. By 1981, it showed an audited circulation of more than thirty-two thousand in the South Bergen area. At one time, it was owned by Macromedia Publishing, but on December 5, 1997, it was purchased by the North Jersey Media Group. During the last ten years, it has grown to broadsheet size at twelve and a half by twenty-one and a half inches tall. It is now composed in color, has simplified its graphics and moved to editorial offices on Lincoln Avenue across from Rutherford's Borough Hall. It has developed an excellent reputation for local reporting and is still delivered to Rutherford residents for free.

Masthead of the *South Bergen News*.

OF COMMERCE AND CONVEYANCE

In so many ways, Rutherford is a microcosm of our nation at its best. Visionaries, entrepreneurs and artists of both local and international repute have lived and worked here. Lofty thinkers and humble workers, pavers of roads and pavers of new ways, builders of commerce and industry and builders of houses have made their homes and careers, and made a difference, here.

UTILITIES

The year 1888 brought the very first Rutherford telephone. The instrument was placed next to the depot at a Lemparts Stationery store. (The railroad station had a perfectly fine telegraphic system, thank you!) Then, in 1895, the Rutherford Telephone Exchange came online at 64 Park Avenue in Knapes Drugstore. By 1907, over a thousand phones were connected, and the exchange was sited at 54 Park Avenue in the Brenner Building. Finally, in 1926, the telephone exchange settled into 40 Orient Way and remains there today.

Gas for public lighting was first made available in 1891 by the Rutherford and Boiling Spring Gas Company extant at Union and Van Winkle in East Rutherford. The company sent over natural gas in the first mains installed along Orient Way, Park Avenue, Chestnut Street and Union Avenue. But almost immediately, gas was being replaced. In 1889, the Rutherford Electric Light Company was first organized, and by 1893 the operation was supplying one hundred incandescent lights for the borough streets.

LOCAL BUILDERS

As the land associations of the 1870s sold off their vast collection of lots, they gave way to more concentration on brokering and building on individual properties. In New

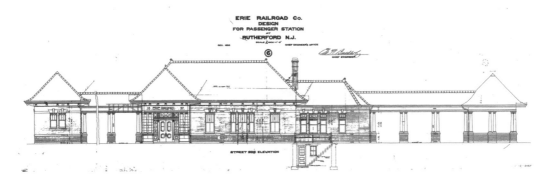

Original plans for the Rutherford train station by Erie Railroad Chief Engineer Charles W. Buchholz.

York newspapers, realtors such as A.L. Watson offered "homes, building plots, tracts and factory sites" in the "best and nearest suburban town." Following the initial wave of settlement in the late nineteenth century, an additional building boom occurred through the first two decades of the twentieth century. This boom paralleled the influx of population that railroaded into suburban spots throughout Bergen County. This is the time when the majority of the borough's current residences were constructed. Most of these homes were what we now call foursquares. Builders brushed aside the filigree of the Victorians in favor of bigger, beefier houses. Their designs were intended to utilize more space on conventional building lots to accommodate larger families. Thousands of these simple, four-bedroom, center-hall homes were erected over and over again by the same builder. An excellent example of an area in Rutherford that contains quality foursquares is centered roughly on the area defined by Raymond, Beech, Washington and Erie Avenues. These houses were constructed by Daniel S. Goss, whose own bungalow-style house is extant at 60 Raymond Avenue.

From an advertisement in the *Rutherford Republican* dated December 21, 1912, Goss claimed to have constructed over fifty houses in the previous five years throughout Rutherford. The homes were offered for $5,000 to $6,500 with "easy terms." Goss built much of Beech Street for the Carlton Realty Company. He also constructed the eclectic cement block and stucco manor house at 46 The Terrace and a terra cotta, block and stucco house at 66 Ridge Road. Christopher C. Walton was an African American builder who constructed four houses on Elm Street. He arrived in Rutherford about 1907 and, as of 1908, lived on the corner of Woodland and Wheaton. Other builders, such as Frederick C. Ogden, who built sixty "Famous Ogden Houses," and C.J. Gregory Construction, built some of the most beautiful streetscapes that remain today.

THE RUTHERFORD TRAIN STATION

The Erie Railroad was initially served by several small wooden structures used for loading and unloading freight, with a crude passenger area and maintenance shed for the locomotives. In 1866, a consolidated wooden station was built. Even though twenty

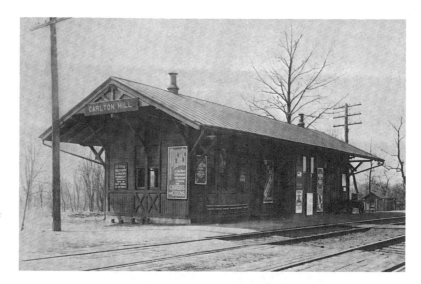

Rutherford's Carlton Hill train station, once located at Jackson and Erie Avenues. A typical design for a simple depot.

trains would arrive every weekday, it was not until the late 1890s that a new station was built to accommodate the growing needs and comfort of the commuters boarding at the Borough of Rutherford.

A station's architectural approach differed with each train line. Some railroads set out formless functional buildings, while others erected elaborate structures. The Erie Railroad in New Jersey found a middle ground, which established functional solid buildings with appropriate accents, complementing their settings and surroundings.

In the 1890s, the Erie Railroad employed Charles W. Buchholz as its chief engineer of the New York Division. In 1896, when presented with the need to rebuild a new Rutherford Station, Buchholz realized how important the station setting was. Rutherford's first trolley franchise was awarded to Union Traction Company on February 4, 1894. Station Square had always been the major radial intersection of the town; now it had nine intersecting roadways and four trolley lines merging at the depot's front door. It was the "first stop from New York" (actually Hudson County) and overlooked both the rural Hackensack Meadows and the rising vista of Manhattan.

Buchholz first expanded the station area to 374 feet by doubling its length, and he planned a building that consisted of an asymmetrical rhythm of structures and colonnades that supported a green tiled roof set into seven hipped, gabled and eventually cone-shaped sections. The exterior walls were smooth, finished brick of a warm orange, with a common bond of tinted mortar, trimmed with a tooled limestone string course and keystones. The same brick face, coursing and colored mortar joints would be repeated in several prominent buildings throughout Rutherford.

At the very southern end of the station, a customer could step up and into a unique circular belvedere. The belvedere (or gazebo) was solid walled brick to waist height, trimmed by six paired columns. This remote structure provided a reflective area with a panoramic view of the final destination of New York City.

The railroad completed construction late in 1898. Rutherford Station provides an excellent example of Renaissance Revival style, with some Queen Anne elements. The

The eastern belvedere of the Rutherford train station.

The signature of Erie Railroad chief engineer Charles Buchholz.

Operating Railroad Stations of New Jersey Historical Survey described the detailing as "classical, including such features as the form of belvedere, the Tuscan columns, keyed lintels and roman lettering."

It is not known why the Erie Railroad's chief engineer, Charles W. Buchholz, was never credited with another station. This would be the only structure to which Buchholz signed his name.

ACCOMMODATIONS

The opening of the new train station only increased the prominence and activity of the area. Many historians credit it with much of the rise in population in the borough. Stepping off the train, passengers were greeted by any number of transportation accommodations. If one required a hired carriage, hack or just a single horse livery, there were stables located nearby on Orient Way, Glen Road, Erie Avenue and Agnew Place. If one needed to "freshen up" a bit, or needed room and board, Just's Erie Hotel was steps away. More lodging could be found up Park Avenue on the East Rutherford side of the tracks. There was also vivid evidence of the boiling springs at the fountain next to Just's Erie Hotel and a watering station for animals in Station Square.

Once out of the station area, numerous overnight accommodations could be found in Rutherford. Stewart's Hotel was just up Park at Franklin. Boarding houses were scattered around town and included the nearby Ames (30 Ames Avenue), the New England (32–34 Highland Cross), Whittier (212 Park Avenue), the Hasbrouck (87 West Passaic Avenue), Audubon (84 West Passaic Avenue), Hawthorn House (92 Mountain Way/Nelson Young's former residence) and the Maples (129–131 Chestnut). The last was a house owned by Mrs. Van Riper and Mrs. G.H. Matthews; it consisted of two separate structures built in 1890–97 and joined together between 1909 and 1917.

The Erie Clam House, originally known as Just's Erie Hotel.

The Hawthorn Boarding House, also the Nelson Young home.

PASSAIC RIVER BRIDGES

Rutherford was still situated on the peninsula bordered by the Hackensack and Passaic Rivers. This geography dictated that most traffic moved north and south. The Rutherford Avenue Bridge was built in 1870. It connected the relatively quiet roads of Rutherford Avenue to the farmlands adjacent to Kingsland Avenue in Clifton, and little else. A quarter century would pass before another permanent bridge would connect Union Avenue to Passaic. The bridge was established jointly by Bergen and Passaic Counties and dedicated on June 11, 1896. The total length of the bridge was 285 feet. Along with the Rutherford Avenue Bridge, the design was a common Pratt Truss bridge with a bottom road deck of metal grating. It was a movable center-swing bridge that was manned from a small shack on the Rutherford side. When a ship approached and needed to navigate under the span, it would sound a horn or steam whistle so the bridge operator could swing open the bridge for clearance. The structure was constructed by the Dean & Westerbrook Company of New York and situated just a few hundred yards north of Waling Jacobs's original settlement. In 1981, the Union Avenue Bridge was renamed for U.S. Army Major Douglas Osborne Mead and his service during World War I. Mead would also be elected mayor of Rutherford. This important steel span would survive ship collisions and be overrun by the 1902 floodwater. Still, it remained in use for over one hundred years.

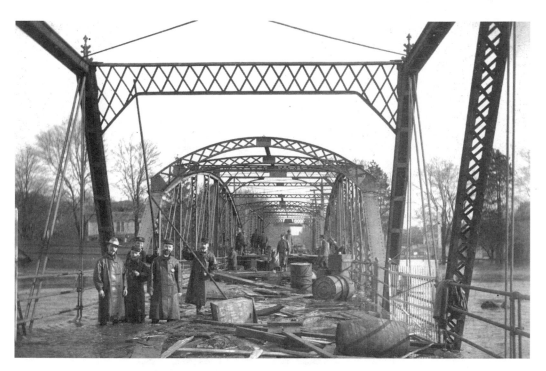

The Rutherford Avenue Bridge during the 1902 flood. *Courtesy of Ann Cole.*

RUTHERFORD'S HIGHWAY "BORDERS": ROUTES 3, 17 AND 21

As early as 1927, plans had been drawn up for a new highway to be called Route S-3 (now New Jersey State Highway Route 3). Originally, Route 3 was to connect the Lincoln Tunnel, opened in 1937, to the western segment of Route 6 (now Route 46). Completion of the George Washington Bridge in 1931, and the finishing of Route 6 in 1940, allowed motorists to travel from the bridge across the entire northernmost tier of New Jersey to the Delaware River. For years, the only automobile route across the meadows was the Paterson Plank Road. Motorists then connected to the Rutherford Avenue Bridge to cross into Passaic County.

By 1937, construction was underway on the very beginning of Route 3 (today's Route 495), as several tons of bedrock were blasted to create a passage through the geological barrier of the Palisade Ridge. The opening of Route 3 in 1939 alleviated traffic congestion through Weehawken, Union City and North Bergen, but travelers farther west still had to use local roads. This was quickly seen as a bottleneck, and a more modern bridge and highway connection was required. Unfortunately, as Route 3 was being pushed through, the largest area of property ever taken by eminent domain in the state of New Jersey would be required. Rutherford homes that were in the path were either demolished or moved to Crane and Van Riper Avenues or the cul-de-sac off Van Riper. The Lyndhurst Presbyterian Church (at Park and Rutherford Avenues), also known as The Academy, was demolished and lost forever.

Route 3 and the Rutherford Avenue Bridge, circa 1946.

The Route 3 Bridge, over Passaic River, was formally dedicated September 12, 1949. Governor Alfred Driscoll gave the keynote address. In the end, over $11 million was expended to complete Route S-3. Eighteen different contractors were employed on the job, which for years was slowed by difficulties in obtaining supplies, equipment and manpower due to World War II.

Route 17 was originally built between 1923 and 1929. New Jersey State Highway Route 17 basically starts at Rutherford and continues north past the New York State border as New York State Route 17. When it opened, it was re-designated as New Jersey Route 2, but in 1941 it was changed back to Route 17. During World War II, it was viewed as an evacuation route away from New York City.

Route 21 began from the original highway north out of Newark, commissioned in 1934 and known as the McCarter Highway. In the late 1950s, the highway was extended northward along the west bank of the Passaic River to connect with Route 3 by 1961. The highway extended past Rutherford to Paulison Avenue in Passaic by 1970 and moved farther north to Monroe Street in 1974. Many old riverside homes and historic structures were removed as the road plowed through sections of the old Acquackanonk area. A Newark-to-Paterson connection was always envisioned, but Monroe remained a terminus for almost a quarter century. At the close of the century, construction finally began on the "missing link" of the freeway that would bring Route 21 to Route 46. Two years later, on December 20, 2000, the entire 14.3 miles were fully opened.

Early Banking in Rutherford

As more wealth was accumulated, Rutherford citizens demanded better, more secure banking. On May 3, 1895, the Rutherford National Bank was organized in a meeting on the second floor of 9 Station Square in the original McMain Building. The bank opened for business on June 27 with a capital reserve of $50,000. Henry Jackson was its first president, and the directors included Julius Roehrs, E.J. Turner, A.W. Van Winkle, Peter Kip, A.L. Watson and William McKenzie. Just before midnight on December 8, 1895, a fire erupted in the large wooden building. Although the firefighters did all they could, the destruction was soon complete. The huge safe of the Rutherford National Bank had fallen two stories and was so hot it could not be opened for days, but the founders were undeterred. Bank director and real estate agent A.L. Watson leased his office adjacent to the Erie Railroad tracks, and the bank reopened and remained there until 1898. During the same year, the bank obtained a corner plot of land at 39 Park Avenue (extant) and commissioned a beautiful Romanesque-style building. A walk-in safe was installed on the first floor, and the building was enlarged in 1909.

By 1920, the bank had outgrown its space and had obtained another corner plot of land at the southwest corner of Ames and Park Avenues. In 1923, the bank chose to construct one of the borough's most impressive buildings. Twenty-four Park Avenue is a handsome neoclassical Beaux Arts structure with a small raised portico. This elevated entrance expressed security and stability by employing four massive fluted Ionic columns to hold up the architrave that originally contained Rutherford National Bank. In 1956, the bank changed names, and "National Community Bank" was inscribed in the Indiana limestone. National Community Bank eventually evolved into one of the largest and most secure financial institutions in New Jersey. It was acquired by the Bank of New York in 1994.

The second Rutherford National Bank Building, 1895–98, extant on the Erie Railroad westbound trackside.

Rutherford National Bank, 24 Park Avenue.

The East Rutherford Savings Loan and Building Association was also formed in 1895, with the guidance of William A. McKenzie and Rudolph Dannheim. In 1939, it combined with the older Rutherford Mutual Building and Loan Association to form the Boiling Springs Savings Bank. This bank has branched out to many communities in northern New Jersey, but it still maintains its headquarters in the Borough of Rutherford.

Two other banks organized early in the twentieth century. The Bergen County Bank of Rutherford was formed in December 1900. The Peoples' Bank and Trust Company of Passaic opened a branch in Rutherford on September 10, 1890, and became the Rutherford Trust Company on February 14, 1910.

STANDARD BLEACHERY

In 1886, John Ward and William A. McKenzie (born 1841 in Glasgow, Scotland) obtained the small pre–Civil War Boiling Springs Bleachery and renamed it the Standard Bleachery. And for good measure, McKenzie also renamed the area Carlton Hill. The factory, at Erie and Jackson Avenues in East Rutherford, had a siding along the railroad that was aligned with the West Rutherford (Carlton Hill) train station. The factory was also close to, or actually owned, a small natural area and pond called, at various times, "Swanwhite Park," "Lake in the Woods" and "Swan Lake." And yes, it did have swans!

Right: William McKenzie of Standard Bleachery.

Below: The Standard Bleachery factory complex.

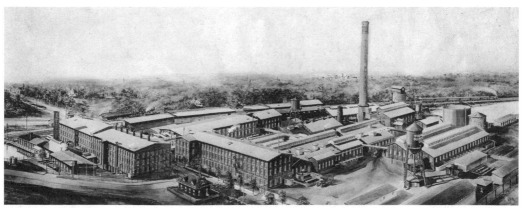

Until the 1930s, the Standard Bleachery employed over six hundred people and owned a Sunday school, community center, playground and fifty local homes, leasing them to its employees in East Rutherford and Rutherford. Eventually, most of the McKenzie family would reside in Rutherford. William A. McKenzie stayed in Carlton Hill and was the chairman of the Boiling Spring Township Committee when a movement was started to abandon the township form of government and to become the Borough of East Rutherford. He was elected the first mayor of East Rutherford in 1894.

NURSERIES LARGE AND SMALL

Just past the bleachery's water area was the large commercial nursery of Bobbink and Atkins. Then immediately across Paterson Plank Road was the Julius Roehrs Nurseries. Lambertus Bobbink was a horticulturist who took salesperson Frederick L. Atkins as a partner in 1898. The firm was best known for supplying high-quality, two-year-old budded roses and ornamental shrubbery.

The Julius Roehrs company actually arrived a bit earlier, in 1864. Julius emigrated from Germany to grow orchids for the industrialist Michael Lienau in Jersey City. Roehrs co-authored one of the first books on orchid propagation in America in 1867. He then decided to strike out on his own and obtained a seventeen-acre collection of land within Union Township in what is today's East Rutherford. He established large fields and greenhouses to propagate stock imported from Europe. When Julius died in 1913, he left one hundred greenhouses on one hundred acres of open fields tended by two hundred workers. The nursery continued until 1969, when the family moved the operation to Monmouth County.

Rutherford also had its own commercial greenhouse in the center of its residential core. Landscaper and florist August Nadler bought ten plots of land on Woodward Avenue in 1871. He opened a greenhouse and had over seven thousand square feet of

Your order received, for which we thank you. Same will have our prompt attention.

Place your orders now for Bay Trees and Ornamental Evergreens.

We have probably the largest stock in the country.

BOBBINK & ATKINS

NURSERYMEN AND LANDSCAPE ARCHITECTS

RUTHERFORD, N. J.

SHIPPING BAY TREES IN SPRING

Bobbink and Atkins nursery.

growing area. After a succession of different owners, the last part of this nursery was disposed of in the late 1990s.

CARPET CLEANING

George B. Holman opened a carpet cleaning factory in 1889. In three years, success compelled him to build a three-story building for upholstering and cleaning at the corner of Park and Highland Cross (151–153 Park Avenue). The ever-social Holman family created a beautiful home next to the factory and also opened another facility in Hackensack. Carpet cleaning gave way to moving and storage, but one of Rutherford's most imposing brick buildings still exists as a warehouse across from Lincoln Park. It is still owned by the Holman family.

GARRAWAY PHOTOGRAPHIC STUDIO

One of the most curious buildings in Rutherford is located at 375 Carmita Avenue on the corner of West Newell. In 1907, this unique structure was commissioned by George Garraway for use as a photographic studio. It was erected and made ready for business in 1909 by the Rutherford Cement Construction Company located at the foot of West Newell on the Passaic. This is one of the best remaining examples of this local company's stylized method of using formed cement over concrete block. The construction company built the foundation for the Lincoln Park Cannon and numerous buildings throughout the borough. At the turn of the century, the use of block and formed cement as a decorative covering was considered quite modern, innovative and fireproof. Although the building was gutted by fire in 1935, the exterior was hardly damaged, and the Garraways rebuilt the interior and recommenced business.

George C. Garraway served in the Spanish-American War and returned to Rutherford to form a business partnership with his brother, Arthur. They opened a store at 10 Park Avenue and sold stationery, cameras and photographic supplies. George sold the store to H.R. Whittridge and immersed himself in photography and the construction of his Carmita Avenue studio. The company made postcards, including many for Whittridge. Most of the early postcard views of Rutherford originated from, and were signed by, Garraway. But postcards were not the main business of the studio. Mail-order catalogues and magazine ads brought in the greatest revenue, and by 1927 the firm required the employment of fourteen men and women. George C. Garraway was a member of the Rutherford Municipal Council from 1936 to 1940, but he resigned in January 1942 to service a classified War Department contract to build and operate two high-speed photo-processing machines. At five thousand prints per hour, the machines were in constant use throughout the war. On October 26, 1952, George C. Garraway, photographer and inventor, died in Hackensack Hospital. The building changed owners several times but remained a photographic studio and processing plant until 2004.

A Bonny Dell Dairy milk bottle.

RUTHERFORD DAIRIES

Many Rutherfordians can remember when Route 17 was still a small highway with farms on either side. Some baby boomers can also remember pony rides around the Rutherford dairylands of Bonny Dell Farms. The dairy was owned by Morgan Lentz and was located roughly where the 301/201 Route 17 North towers are today. Home milk delivery was still common into the late 1960s, and before that local farms were important for a fresh dairy supply. Besides Bonny Dell, there were Elycroft ("Elycroft Dairy: The Clean Sanitary"); Toense & Thonack; Rutherford, New Jersey, Milk and Cream; and A.C. Jillard. Some of these functioned as local distributors, but there were many dairy farms located nearby in the wide open meadows.

COMMERCIAL USE OF THE RUTHERFORD NAME

As in many growing population centers, companies incorporated the Rutherford name as if they were originally formed within the Borough of Rutherford. As Rutherford became a magnet for commerce, it attracted many businesses. Some were not located within the borough's borders, but they utilized a Rutherford postal address or just the Rutherford moniker in their name. Julius Roehers, Bobink and Atkins and Becton, Dickinson were all located in East Rutherford but used Rutherford as their supposed corporate location.

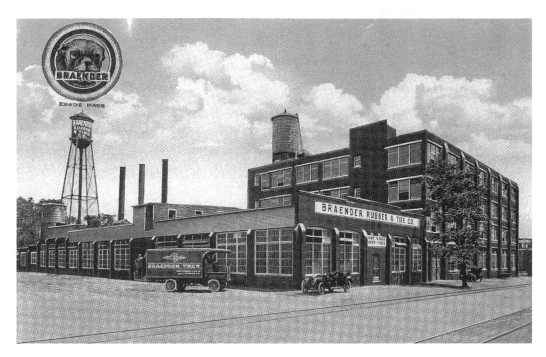

Braender Rubber and Tire Company, 481–527 Paterson Plank Road, East Rutherford.

Braender Rubber and Tire Company, located at 481–527 Paterson Plank Road (extant) at the borderlines of Carlstadt, Wallington and East Rutherford, even used Rutherford's mascot, the bulldog, as its own and sported a Rutherford address. The Rutherford Rubber Company (1910), manufacturers of Sterling clincher tires, horseshoe pads and heels, located in the industrial park off of Maple Avenue (it may be seen as one looks to the left crossing the Montross Avenue Bridge), and the Rutherford Machinery Company, at 401 Central Avenue in East Rutherford, were two of the many firms that chose to identify with the borough.

THE MEADOWLANDS

The geological history of the wetlands east of Rutherford is the story of receding glaciers and their freshwater drainage into the Atlantic Ocean. Fifteen thousand years ago, the surrounding area of glacial Lake Hackensack began to melt and drain to expose the underlying bedrock. This natural evolution formed the surrounding Hackensack Valley and defined much of the Rutherford area.

The human use of these meadows has had a more questionable effect. In the early nineteenth century, cedar logging and salt grass harvesting was very common throughout the meadows. Salt grass was used as winter feed for livestock, and cedar's durability made the wood valuable. After the Civil War, many plans for draining and developing the land arose because the proximity to New York made the land more valuable as a speculative investment. Spencer B. Driggs partnered with real estate developer Samuel Pike to reclaim central areas of the meadows. Combining a system of pumps, dikes and tidal

Meadows dike and draining crews, 1867.

gates, they were on a roll until the financial depression of 1873, when they were forced to abandon their plans. By the beginning of the twentieth century, most of the cedar was depleted and salt grass was ignored as animal husbandry became antiquated. Much of the watershed in the upper Hackensack River was being dammed and consumed by reservoirs built by the Hackensack Water Company. Still, the meadows grew in potential value as various industries, such as truck farming, warehousing, manufacturing and brick making, moved in.

When was the first shovelful of refuse turned onto the meadows? It may have been by the Native Americans as they moved off hunting grounds and left temporary lodgings behind. By the middle of the last century, the marshes were consuming building debris, or "fill," and then just household garbage from New York City, Newark and surrounding suburban towns. It seemed as if every municipality had its own sanitary landfill or dump site in the meadows. Dredging and filling replaced the draining and diking practices of the 1800s.

Much of the dumping was illegal, and regulation was needed. New Jersey Governor Richard Hughes persuaded the state legislature to enact the Hackensack Meadowlands Development Act in 1968. Encompassing approximately thirty-two square miles, it includes all or parts of fourteen municipalities in Bergen and Hudson Counties. Then Hughes's successor, Governor William Cahill, crafted legislature to create the New Jersey Sports Authority Act of 1969. This directed a platform to develop a major sports and entertainment center in the heart of the meadows. The first harness race took place on September 1, 1976, at the Meadowlands Racetrack, and Giants Stadium opened on October 10. The "marsh," "dumps," "swamps" or "meadows" were henceforth to be officially known as "The Meadowlands."

Chapter 10

OF CASTLES AND KINGS

Among the countless stories of centuries of citizens are those of seven individuals who famously changed the face and legacy of Rutherford. They bequeathed gifts of their talents that were architectural, literary, educational and commercial that will stand as contributions to all of our lives.

IVISWOLD: THE MAN AND THE CASTLE

Before there was "Iviswold—The Castle," David Brinkerhoff Ivison was a successful publisher whose company, Ivison, Blakeman and Taylor, merged to become the national textbook publisher the American Book Company. He built a beautiful residence that fronted Union Avenue. By 1867, Ivison had combined four lots into a large property bounded by Washington, Wood and Union Avenues. In addition to the house, there were barns, a silo and greenhouses. His neighbors were the Stewarts, Beckwiths and, just to his east, Henry Kip, on his large "Kip Farm" across Union. Looking across the avenue and over Kip Farm, David Ivison could see Floyd W. Tomkins's "Hill Home" on newly formed Montross Avenue. Tomkins's home was a grandly sited, sandstone, two-and-a-half-story, mansard-roofed mansion that befitted one of the area's wealthiest land speculators. Completed in 1869, it was a substantial dwelling, having cost $34,000.

As David Ivison's success and wealth were increasing, times turned tough for Tomkins. During President Grant's term in office, the Great Panic of 1873 began from overambitious financing of the nation's railroads. The New York Stock Exchange closed for ten days. Credit dried up; foreclosures and bank failures were commonplace. Factories closed their doors, costing thousands of workers their jobs, and most of the major railroads went bankrupt. Rutherford's original booster, Floyd Tomkins, was hit hard and never fully recovered. By 1879, Mutual Life Insurance foreclosed his mortgage on Hill Home.

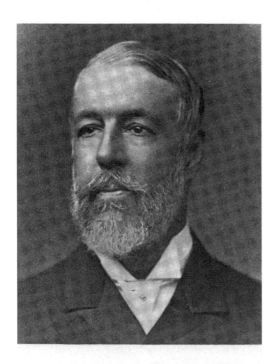

Left: David Brinkerhoff Ivison.

Below: Iviswold construction, 1887. *Courtesy of Fairleigh Dickinson University.*

During this period, Ivison slowly assembled property surrounding Hill Home, and by 1887 he had purchased the entire estate and more. When he acquired Tomkins's home, David Ivison made it known that he intended to enlarge the house and name it Iviswold ("Ivison" plus "wold," Middle English for "un-forested plain"). He turned to architect William H. Miller from upstate New York to realize his vision.

Miller was associated with Cornell University and the City of Ithaca. During his lifetime, he designed eighty buildings in that area, including many for the university. The architect drew heavily from various European inspirations and, in 1887, set about to work for Ivison. Miller did not demolish Hill Home but rather worked with the original stone structure to swallow it into his new, larger design. He had brownstone obtained from the Belleville quarries that matched the encapsulated Hill Home walls.

Miller designed the form of the building to be very irregular and utilized many different roof shapes and slopes. The structure incorporated components of the Queen Anne and Richardsonian Romanesque styles, but most people would recognize it as chateau-esque. In the end, it was not a stretch to describe it as a castle. Miller also created and finished much of the lavish interior. The building cost $350,000 to remodel and was ready for the Ivison family to occupy by 1888. Today, it remains one of the best preserved and most architecturally significant examples of "the American Country House" in New Jersey.

Ivison landscaped the estate and had Miller design a smart-looking carriage house with the same materials and finishes. The Iviswold carriage house is now the headquarters for the Rutherford Woman's Club and was designed to fully harmonize with the manor house.

David Ivison enjoyed his estate for a little over a decade. It seems that by 1901 the family had completely vacated Iviswold. David Ivison was possibly in poor health. He died in his New York town house on April 6, 1903.

David Ivison may have showed his wealth, but he proved to be one of the most generous citizens in Rutherford. When he moved to town, he presented the Presbyterian Church with a new building at the corner of Chestnut and Park (since replaced by the modern edifice of Rutherford Public Library). When the congregation outgrew the

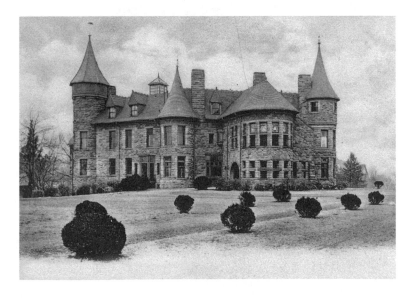

Iviswold, circa 1908.

original structure, Ivison helped obtain a larger plot of land for a new edifice. He then designated that the old church structure should be used as the town's first public library.

William Carlos Williams and Edgar Irving Williams

Two brothers, native Rutherfordians, would change the face of the borough and inspire the world with their outstanding contributions to literature and architecture. On September 17, 1883, William Carlos Williams was born, and thirteen months later, on October 5, 1884, Edgar Irving Williams was born. The lives of both William and Edgar seemed to begin and end with Rutherford.

In 1881, before the brothers were born, the Williams family moved to 131 Passaic Avenue (now West Passaic). Their father, William George Williams, was an English immigrant who manufactured and sold the popular fragrance Florida Water for Lanman & Kemp. Their mother, Raquel Helene (Elena) Hoheb, was born in San Juan, Puerto Rico. For a good part of their youth, the household was shared with their paternal uncles, Godwin and Irving, and grandmother, Emily Dickinson Wellcome. Their home was across the street from Grace Church and a few hundred yards away from the still-evolving Iviswold estate. The brothers were inseparable. As William Carlos would note in his 1948 autobiography, " Ed and I grew up together to become as one person. All that I experienced as a growing child and up to the time of my marriage was shared with him." The boys attended public school in Rutherford until they were in the eighth grade at Park School. Both were athletically inspired and played baseball, with William as pitcher

The Williams family on their porch at 131 West Passaic Avenue. *Courtesy of Rutherford Public Library.*

and Edgar his catcher. They rambled throughout the town's still-rural landscapes, Kip Farm and the meadows.

The family was deeply involved with the close-knit Unitarian Church on Home Avenue. Often, their mother was asked to play the piano during services, and their father was church superintendent for eighteen years. During 1897, their father was called away to set up a fragrance manufacturing operation in Buenos Aires, and the teenage brothers traveled with their mother to Geneva, Switzerland, to study at the Château de Lancy. For the next two years, they lived in Europe and eventually rented a flat in the Montmartre area of Paris. While there, they attended the Lycée Condorcet. They returned home in 1899 and were enrolled in Rutherford's first high school class; however, William Carlos found the teaching "not distinguished" and did not excel. At this point, the family decided to have both boys attend the Horace Mann School near Columbia University in the Morningside Heights area of Manhattan. Each morning, they began their marathon trip to school by boarding the 7:16 a.m. train from Rutherford Station.

At Horace Mann, William faced a life-changing crisis. While running track at the school, he collapsed with a heart ailment and was advised not to ever participate in sports again. His first poem reflected his present adolescent angst:

A black, black cloud
flew over the sun
driven by fierce flying
rain.

In his autobiography, William recounts that first creative moment as "the mysterious, soul-satisfying joy that swept over me…that was only mitigated by the critical comment which immediately followed it: How could the clouds be driven by the rain? Stupid. But the joy remained. From that moment I was a poet." The fiery passion and self-criticism would be forever a Williams trait.

A career in some branch of the arts, visual or literary, beckoned. His heart lay with poetry, but "I instinctively knew no one much would listen…I wasn't going to make any money by writing." Always prudent and uncompromising, he vowed, "No one. And I meant no one (for money) was ever (never) going to tell me how or what I was going to write. That was number one." He then focused on medicine as a career, realizing that the income would allow him the freedom to write as he pleased.

William was admitted into a unique program at the University of Pennsylvania medical school. By satisfying a set of basic college entrance requirements, he qualified to bypass most of his undergraduate study and, in 1902, began the course of study for his medical degree. He was just nineteen and next-to-youngest in a class of 120. At Penn, he both wrote and was accepted into the Mask and Wig theatrical club. This was one of William's most inspirational periods as he became acquainted with the poets Hilda Doolittle ("H.D.") and Ezra Pound, and with the painter Charles Demuth. These college friendships provided the encouragement and critical support that the young poet needed. William received his professional degree as a doctor of medicine in 1906. From 1906 to 1909, he interned in the old French Hospital on New York City's

west side. He found time to write verse between patients and self-published a first book, *Poems*, in 1909. He was aided in the effort by Rutherford historian and professional printer Reid Howell. *Poems* was reviewed in the *Rutherford American* on May 6, 1909, but it sold only a few dozen copies.

After his internship in New York City, he did postgraduate studies in Europe. When he returned to Rutherford in 1910, he began a medical practice as a simple town doctor that would last until 1951. During 1913, Ezra Pound helped Williams secure an English publisher for his second book, *The Tempers.* Four years later, he compiled his first distinctly original collection, *Al Que Quiere!* ("To Him Who Wants It!"). This was published in Boston in 1917, and it began a continual outpouring of poetry, short stories, plays, novels, essays and an autobiography.

As the poet, Dr. Williams gave voice to the modest town of Rutherford and the world around it. Subjects including the Passaic River, Erie Railroad Station and Hackensack Meadows all found unique resonance in his work. At times, the voice was grandly epic; at others, plain-spoken; and, at once, critical and then compassionate—but always compelling. His simple observations on Paterson and its Great Falls produced the poetic sequence *Paterson*, which he lovingly crafted for nearly twenty years. No other writer comes to mind who has expressed a greater sense of belonging to a place. Williams's career in poetry was made in large part by his passion for his home and what he perceived around him. From his vantage point at 9 Ridge Road, he observed the heart and pace and people of his town. He wrote of flowers he tended and of the reeds and marshes in the meadows nearby. He wrote of his patients and their struggles and the simple joys of life. Where initially the poet was at odds with the physician, over time Williams's vocations intertwined and integrated.

One might assume that Williams led a completely provincial life. This was not the case. His education and childhood visits to Europe aside, he associated with many of the notable artists of his day, among them the poets Marianne Moore and Wallace Stevens; avant-garde painters Marcel Duchamp and Francis Picabia; and photographers Alfred Stieglitz and Charles Sheeler. Many weekends he slipped into the creative caldron of New York's Greenwich Village and arrived home inspired and rejuvenated.

Both his friendship with the politically and socially controversial Ezra Pound (admirer of fascist dictator Benito Mussolini) and the frank sexuality in some of Williams's writing portrayed a personality unconcerned with the opinions and mores of others. Any controversy was set aside when the Library of Congress asked him to serve as the national "Consultant in Poetry"—poet laureate of the United States—in 1952. Unfortunately, he did not serve, as that year he suffered a stroke severe enough to cause him to turn over his medical practice to his son, William Eric Williams, and to significantly reduce his writing.

But what of Williams's brother, Edgar Williams? In his early years, Edgar was witness to amazing changes all around him. Living across the street from Iviswold, he watched as the sturdy stone structure of Tomkins's Hill Home was enveloped and reconstructed into a castle. He boarded trains to New York at a new, architecturally unique Rutherford train station, and his hometown was demolishing and re-erecting a new version of his old Park School. At the beginning of the twentieth century, architecture and civil engineering were propelled by revolutionary materials and techniques transforming cities and towns

alike. Edgar saw all of the incredible potential and decided he wanted be a part of the modern movement.

Edgar enrolled in the Massachusetts Institute of Technology and launched his study of architecture. He was very focused, excelled and became involved in many professional and educational associations. He received the degree of bachelor of science in 1908 and master of science in 1909. He then studied at the American Academy of Rome for three years, during which he was elected to the academy's Society of Fellows for Architecture and received the first Prix de Rome in 1909.

After his return to Rutherford, he became an architectural designer for the firm of Welles Bosworth in New York. The first of his many Rutherford projects was the 1914 landscaping and plaza improvement of the Rutherford Public Library facility. While William Carlos was constructing the art of words, Edgar Irving's gift manifested itself in the visual arts of sketching, drafting and painting.

The brothers continued to write to each other throughout their college years. William Carlos both found his unique voice as a poet and maintained his path in medicine. But about 1912, there seems to have been a rift in their relationship. William wrote:

> *Ed and I frequently "went with" sisters after we grew a little older. Finally, he became engaged to one and I to the other whom I married, though his engagement was broken off. That was the end of my youth. For it was the end of my passionate identification with my brother. I have never been able to make out quite what happened at that time, for something profound did happen, something moving and final.*

Architect Edgar Irving Williams, circa 1928.

The William Carlos Williams House, 9 Ridge Road.

In December 1912, William married Florence ("Flossie" or "Floss") Herman. Their first son, William Eric Williams, was born in 1914, and their second son, Paul, was born in 1916. On September 16, 1913, Edgar married Hulda Gustafva Olsen, and they had four daughters: Ingrid Helene, Hulda Palamona, Edith Marja and Christina Nilson.

When Florence Williams became pregnant with William Eric, her father, Paul Herman, helped the couple purchase a local dentist's house at 9 Ridge Road (extant). This would be their home, and the center for William's work, both as a physician and poet, for the rest of their lives. William and Edgar's father died on Christmas Day 1918. Edgar and his family continued their lives at his father's house at 131 West Passaic.

Edgar Williams was intensely moved by the catastrophe of World War I. During the height of the United States' involvement, he volunteered to be a director of the Genoa branch of the American Red Cross in Italy. As the war ended and he returned to his hometown and family, Edgar felt moved to memorialize the service and loss of life of his townspeople. Working with the borough's War Chest Committee, he designed an elegant Romanesque column at the intersection of Chestnut Street and Park and Passaic Avenues. The site was an inspired bit of planning, as a few years before Rutherford Mayor Gunz had expressed his desire to see this plaza become an "Isle of Safety." On the memorial column, Edgar inscribed the names of the nineteen Rutherford boys who died for their country in the Great War. At the dedication on Memorial Day, May 30, 1920, he stated his concept of the Soldiers' and Sailors' Monument:

> *The monument has a generally vertical mass chosen to indicate, as an old French axiom says, "a finger pointing to Heaven"...The lower base will contain the records of Rutherford's achievements during the World War. The bronze cover plate shows an American eagle standing on a fasces. The fasces is a group of reeds tied about an axe and is the symbol of law and order. The main tablet bears the names of the nineteen men*

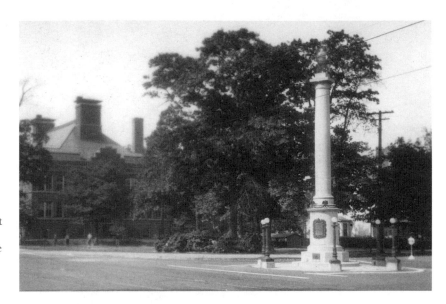

The World War I monument in its original setting before the post office and Borough Hall renovations.

who died in the war…On either side of the tablet are reversed torches, the symbol of lives passed from this earth. Intertwined about the torches are laurel branches indicating glory and honor…The shaft bears the names of the major engagements in which our Rutherford boys took part. At the very top is a tripod from which a flaming light springs. The tripod a symbol of sacrifice and the flame symbolizes the light which our boys helped give to the world; light always pointing upward as the memory of these men who died for their convictions and their country shall always be.

This would be Edgar's only freestanding monument. It was the largest and most prominent piece of art in the borough and was located within one of the most attractive and important intersections in town. The monument expresses much of the civic identity of the borough and anchors all of the most important public structures and their streetscapes. The intersection is the terminus of four separate and distinct avenues and has six corners.

Edgar was a partner in Williams and Barratt from 1920 to 1928. He gave up his MIT tenure to become a professor at the Columbia University School of Architecture, a position that would last for over twenty-five years. Throughout his career, he assumed architectural leadership roles in New York City and the United States. He established a solo practice at 101 Park Avenue in Manhattan.

Edgar's commissions were quite varied as to scale and use. While he was designing a new firehouse for Rutherford's West End Fire Company, he was asked to redesign the Manton B. Metcalf Residence in Llewellyn Park, South Orange, New Jersey. Although his work was national in scope, he always returned to Rutherford and continued to make great contributions to the borough's civic architecture.

In 1935, Edgar was chosen by the federal government to be the architectural designer for the final home of the Rutherford Post Office (extant at 156 Park Avenue). This project was sited on a corner facing his World War I monument and alongside the soon-to-be-started

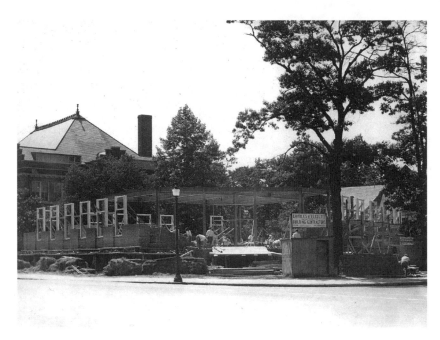

Rutherford
Post Office
construction,
1935.

Park School/Borough Hall project. As with Borough Hall, it was to be assisted by the Works Progress Administration but built by Charles Vezzetti Inc. Williams designed the new post office in an interesting Romanesque Revival style. It was dedicated on January 18, 1936.

During the next two decades, Edgar Williams was very busy with renovations to the Andrew Carnegie Mansion in New York; Morven, the New Jersey governor's mansion in Princeton; and the Brinckerhoff House War Memorial Library in Wood Ridge, New Jersey. New commissions included the Donnell Library Center (New York Public Library); Bankers Federal Savings & Loan Association building, New York; the administration building for the 1939 World's Fair, New York; the municipal building of Carlstadt, New Jersey; and the first building commissioned by Fairleigh Dickinson University, Becton Hall. Although he was a Columbia University professor, Williams maintained a close association with Fairleigh Dickinson, where he occasionally taught and advised on art curricula, but it was more than just an academic relationship. From his porch, he could watch his Becton Hall rise, as he had Iviswold when it was being built. Actually, if he desired, he could step out onto West Passaic to glimpse his World War I monument and post office in the distance. During this time, he was appointed a member, and then president, of the Rutherford Planning Board and was honored with the first Rutherford Citizen of the Year Award in 1946 by the Rutherford Chamber of Commerce. During the same period, he was decorated knight of the Royal Order of Vasa, First Class, by King George V of Sweden (1944).

Two Rutherford projects exemplify both Edgar's respect for historic preservation and his professional vision of his hometown's future.

When the medical supplier Becton, Dickinson and Company was expanding in the mid-1950s, it was set to demolish a nineteenth-century Dutch colonial structure called the Ackerman-Outwater House (originally at 162 Hackensack Street, East Rutherford).

An Edgar Williams sketch of the Kettel–Ackerman complex, 1955. *Courtesy of New Jersey Historical Society.*

Edgar Williams convinced Fairleigh Dickinson University President Peter Sammartino to save the Dutch house by allowing Williams to move it (stone by stone) and join it to the university-owned Yereance-Kettel House at 245 Union Avenue. The Yereance-Kettel House was the same historic structure once owned by Floyd Tomkins and then sold to architect George Woodward. This structure was already being renovated by Williams for Fairleigh Dickinson's educational use. By 1957, the Ackerman-Outwater House was successfully moved and joined to the Kettel House. This proved to be an outstanding solution for all parties and greatly aided the structures' continued preservation.

Paradoxically, during the same period, the borough commissioned Edgar to renovate the beautiful but antiquated Rutherford Public Library. The brownstone structure was little changed from when it was the original Presbyterian church. Electricity, heating and some semblance of offices and bathrooms were evident, but there was little else. It was drafty, dark and generally inappropriate as a modern library for a growing town. Edgar drew up plans to add a large bank of windows facing Chestnut Street. His plans were accepted, and the borough solicited bids. One was accepted; however, after a few months the contractor announced that he could not fulfill the contract. Williams went back to the drawing board but realized he had a white elephant on his hands. For the sake of the town's improvement, he then suggested demolishing the entire structure, one of the most cherished buildings in the borough. After much public debate, Edgar's rationalization won out. Construction took place during 1957 and 1958.

It was claimed that stone from the original church façade was incorporated in the entranceway, but former borough historian (and town purchaser at the time of construction) Fred Bunker believes the stones were too worn to be used again. The new

Above: Edgar I. Williams's, Rutherford Public Library sketch, 1956. *Courtesy of Rutherford Public Library*.

Left: William Carlos and Edgar Irving Williams, circa 1960. *Courtesy of Rutherford Public Library*.

library featured a modern façade that was a gigantic step away from the old familiar structure. The new Rutherford Public Library would evolve into one of the most modern resources in the Bergen County Cooperative Library System. It was the third original structure designed by Edgar Williams to be set within the town's most important civic plaza, and one of the last projects he would design for Rutherford.

It could be easily argued that Edgar Williams was far better known, during the span of his career, than his internationally famous brother—at least in Rutherford. Most local people regarded William Carlos as just "Doc Williams" and knew little of his artistic measure. During over forty years as a doctor, he tended the sick bodies of Rutherford, delivered over two thousand babies and became the head of pediatric medicine at Passaic General Hospital, but the poet was always writing and accumulating a body of work that he completed approximately two years before his death at age seventy-nine. Two months after his death on March 4, 1963, in Rutherford, his final book won the Pulitzer Prize for poetry.

William Carlos Williams was buried in Hillside Cemetery, Lyndhurst, New Jersey. His brother Edgar died eleven years later at age eighty-nine in New Milford, Connecticut, on January 1, 1974.

Becton, Dickinson and Company

One of the greatest success stories of Rutherford is Becton, Dickinson and Company ("BD"). Today's thriving international corporation was founded in 1897 by the partnership of two medical supply salesmen, Maxwell W. Becton and Fairleigh S. Dickinson. Their paths happened to cross at a train station restaurant in Texarkana, Texas. Both were originally from North Carolina and coincidentally shared the same birthday, August 22. Mr. Dickinson, born in 1866, was older by two years. Within a few months, they decided to combine their efforts to sell thermometers and imported European syringes. The business opened in September 1897 at 45 Vesey Street in Manhattan. In October, they made their first sale of an imported Luer all-glass syringe for $2.50. Seven years later, the partners bought the Philadelphia Surgical Company and the Wigmore Company. Both acquisitions were manufacturers of surgical, dental and veterinary instruments.

The partners had moved into an office on Hudson Street in New York but were looking to establish a manufacturing plant somewhere outside of Manhattan. As the BD archivist, Mae Savas, explains:

> *Anton Molinari manufactured medical products in Woodridge, NJ; he became a supplier as well as close friend and then a partner. When it appeared that they needed a larger plant, the three explored the area near Molinari's home and settled on 28 lots on the corner of Cornelia Street in East Rutherford. The property was purchased for $20,930, and construction was started in 1906.*

With the possibility to live almost anywhere, the partners must have thought highly of the Borough of Rutherford. They both chose to live on Ridge Road in beautiful but

Above: Maxwell W. Becton and Fairleigh S. Dickinson, founders of Becton, Dickinson and Company, Inc. *Courtesy of BD archives*.

Left: The clock tower at Becton, Dickinson headquarters, East Rutherford, circa 1962. *Courtesy of BD archives*.

modest homes. In the same year, Becton, Dickinson and Company was incorporated in the state of New Jersey and established a large manufacturing facility in East Rutherford. It was the first factory in the United States built for producing thermometers, hypodermic needles and syringes. By 1907, the twenty-eight acres contained the corporation's headquarters within a handsome brick building that paralleled the north–south axis of Hackensack Street. One of the main features was a commanding tower with a huge Seth Thomas four-sided clock. It was said that Mr. Becton required the clock tower to be high enough so that, when he walked to work down Park Avenue, he could check his watch. In 1912, the clock tower was the setting for several scenes in the action film *In Again, Out Again* staring Douglas Fairbanks. However, even as the new facility was coming online, the company still relied heavily on quality European imports. The Surgical Supply Import Company of New York was the next important acquisition.

As the United States entered the First World War, Becton, Dickinson's imports dried up, forcing its own manufacturing to make up for the loss while meeting an even larger demand for its own products. The former president of Surgical Supply, Oscar Schwidetzky, had stayed with Becton, Dickinson after the acquisition of his company. Mr. Schwidetzky brought an important new product into the mix when he developed a new "All Cotton Elastic" ("ACE") bandage. The company generated $1 million in sales just two decades after the partnership was founded.

Some of the pioneering products made by Becton, Dickinson were the mercurial sphygmomanometer (an instrument for measuring blood pressure), syringes designed specifically for insulin injection and the binaural stethoscope. An important breakthrough was the Yale Luer-Lok tip, which caused a hypodermic needle to be more securely attached to a syringe. This innovation was developed by Mr. Dickinson and is still the standard in use today. Over the next thirty years, the original structure of the headquarters expanded lengthwise and added a third floor. The company footprint increased in South Bergen as it acquired surrounding land and buildings for more manufacturing and offices.

The family-run business was one of the largest employers in the area and over the years created thousands of local jobs. As their wealth increased, the founders played important roles in Rutherford's development. Both partners were involved with the Rutherford National Bank and became benefactors for the early development of Fairleigh Dickinson College. In 1948, the sons of the founders, Fairleigh S. Dickinson Jr., president, and Henry P. Becton, vice-president, took over company leadership. During the sons' twenty-four-year management, BD expanded to be a worldwide leader, made a successful transition into sterile disposable products and became a public company.

In 1977, BD moved its executive office to a temporary space in Paramus. The original facility ceased to be headquarters, and a 140-acre parcel of land was acquired in Franklin Lakes, New Jersey, in 1982. Manufacturing continued in East Rutherford, but it was just a matter of time. In 1992, much of the land was sold to the Federal Reserve Bank, and the BD presence in South Bergen was shuttered. When the company moved, it carefully removed the clock and reinstalled it at the Franklin Lakes headquarters.

The original partners and their families remained great friends and lived in neighboring Rutherford homes at 140 Ridge Road (Becton) and 185 Ridge Road (Dickinson). They passed away at close to the same age and within three years of each other.

An aerial rendering of the Becton, Dickinson complex in East Rutherford, circa 1958. *Courtesy of BD archives.*

Hillside Cemetery was founded in 1882 and is the final resting place for many Rutherfordians. One of the most prominent settings are two well-tended areas set side by side. In the center of the cemetery are the Becton and Dickinson family plots, which contain the graves of Maxwell Becton and Fairleigh S. Dickinson, two men who rose from humble beginnings in North Carolina, became business partners, created one of the largest medical supply corporations in the world but remained Rutherford neighbors for most of their lives. At the foot of Mr. Becton's grave site is a bronze sundial on which are carved the eternal words: "Grow old along with me, the best is yet to be."

PETER AND SALLY SAMMARTINO AND FAIRLEIGH DICKINSON UNIVERSITY

Peter and Sally Sammartino were always together in love and spirit. Peter met Sylvia "Sally" Scaramelli when they were attending a social function at New York University. Sally had attended Rutherford High School and graduated Smith College in 1925. She received her master's degree in history from Columbia the next year. Peter was a founder of and faculty member at the innovative New College at Teachers College, Columbia University. Peter grew up around the Lower East Side of New York City and graduated from City College.

Right: Peter Sammartino and Sylvia
"Sally" Scaramelli about 1933.
Courtesy of Fairleigh Dickinson University.

Below: Scaramelli House, 220
Montross Avenue.

In early 1933, Peter was courting Sally in her family home at 220 Montross Avenue (extant). Her father, Louis Scaramelli, was a member of the planning commission and a director of the Rutherford National Bank. As Peter and Sally were having drinks on her porch facing Montross, they reflected on the sad condition of the then-abandoned Iviswold Castle. After David Ivison's death, his heirs had disposed of the castle and seven acres of adjoining property on the open market. The estate went through a succession of owners. Solomon Milton Schatzkin, a local builder and businessman, assumed ownership in 1906 and renamed it Elliot Manor. His family inhabited the castle for the longest stretch of any homeowner, during which time Mr. Schatzkin added a west-side second-story addition and the upper-floor pool. The Union Club bought the castle and grounds in 1925 but lost ownership as the Depression took hold. When all attempts at resale failed, it was taken over by the Rutherford National Bank, and by 1933 it was empty.

In his autobiography, Peter would write: "One day I was sitting on the veranda of the house of my future father-in-law, enjoying two martinis. Had I just one, I doubt whether Fairleigh Dickinson College would be in existence today." As Peter and Sally talked about the castle, Peter was reminded of his experiences in progressive education in Columbia's New College. It then occurred to them that the castle might be a home for a new college.

Their dream took shape when the couple turned to the Rutherford National Bank for assistance in obtaining the use of the castle for a college. They commissioned a board of fifteen advisors that represented the surrounding area high schools. Rutherford was represented by high school supervising principals Guy L. Hilleboe and Wilmont Moore, and the adult school director Harold A. Odell. While the planning took place, Peter and Sally were married at St. Mary's Church in Rutherford on December 5, 1933.

It would take many years' organization, but by early December 1941 everything seemed in place. Sally's father and Peter assembled $30,000 of their money and asked Fairleigh S. Dickinson if he could match their total as an investment in the school. With that assistance in place, Peter and Sally now had control of the thirty-six-room castle and a total of twelve acres of surrounding property for a spacious campus. The two-year junior college, named in honor of its chief benefactor, Fairleigh S. Dickinson, began on December 3, 1941. Four days later, Pearl Harbor was attacked.

Faced with the prospect of having few, if any, male students, the board of advisors reconvened immediately following the national shock. After lengthy discussion, it voted unanimously to go forward and fully support the college. On September 12, 1942, Fairleigh Dickinson Junior College opened with a total of 153 day and evening students. Its first class included 59 women and 1 man. Initial course studies were both practical and cultural, and included secretarial, journalism, sales management, photography, fashion, traffic management, drafting and art classes. But even as the Second World War commanded attention and college-age servicemen, plans were being made to expand into the surrounding campus.

Although an endearing building, the castle presented a limited amount of classroom space. If a student needed to purchase a book, he had to duck under the grand staircase and into the tiny nook that was the bookstore. Most significant was the fact that, once the war was over, a flood of GIs would need to resume or start their education.

In 1945, the Sammartinos commissioned Rutherford architect Edgar I. Williams to design the first new building to be erected for Fairleigh Dickinson College. Edgar was already art advisor for the college and a professor of architecture at Columbia University. The new building was to be named in honor of Maxwell Becton, who was the other major supporter of the school and partner in Becton, Dickinson and Company. Williams sketched several collegiate concepts, and the selection was a large Colonial Revival–style structure in a utilitarian rectangular form. This side-gabled, common-bond brick building is two and a half stories, with two end wings set back in height and depth. It featured a square belfry (clock added in 1967) and several keystoned oculi on the second floor. In 1946, Becton Hall was opened to accept the onrush of matriculating students.

The school grew rapidly and was a fully accredited four-year college by 1948. A collegiate sports program was initiated, and in 1950 a gymnasium was commissioned, with other buildings to follow. By all accounts, Fairleigh Dickinson was a progressive school. Sally and Peter were career educators and had extremely active roles in development. They could be found everywhere on the campus. Sally headed admissions and worked on student life issues. Peter guided curriculum, but also rolled up his sleeves during construction. The college offered an innovative educational environment. It stressed good nutrition, sought a diverse international enrollment and expected a high degree of student and faculty involvement. When the small Hesslein Textiles Building (next to the Grace Church Parsonage on West Passaic) was commissioned, only enough revenue could initially be found to erect the shell of the building. The students and faculty met

Becton Hall, designed by Edgar I. Williams.

and voted to go forward and finish the building, using their own talent and labor. It opened in 1952.

In the next decade, the thriving college acquired two additional campuses. The Teaneck Campus (1954) included the first dental school in New Jersey and was an expansion of the former Bergen Junior College. The Florham-Madison Campus (1957), originally the large Twombly estate, established the school's innovative Institute of Research. Graduate coursework was added by 1954, and in 1956 the college was granted university status. In Rutherford, the Messler Library was built next to the castle and, in time, became a New Jersey State Library Repository for documents. In a little more than twenty years, FDU had enrolled sixteen thousand students on three campuses, employed eight hundred teachers in fifty-five buildings spread over six schools and established an $8 million endowment. Students were adding to the housing-limited enrollment by finding temporary residency in local homes. International students added the flavors of diverse cultures.

Rutherford's economy was bolstered by student and faculty patronage of the Park and Union Avenue merchants. To impress this fact, Sammartino once paid the college staff in silver dollars. When the odd coins started to circulate, the local merchants realized how beneficial the school was to their livelihood. Soon, FDU became the largest employer in the borough. Still operated from its original campus in Rutherford, it eventually became the largest private university in the state of New Jersey. Many people who originally came to Rutherford for their education stayed for the rest of their lives.

In the last part of the 1950s, a student union building was constructed on the Rutherford campus; however, in the next decade it became apparent that the campus would not be able to expand much past its original footprint. Having multi-story buildings and thousands of cars converging in a residential area of town was not desired by the borough's population. Over the years, the university had swallowed up many of the surrounding houses on Fairview and Montross Avenues to utilize for classrooms, publishing offices, alumni offices and art studios. As was allowed by law, each time a residential property was absorbed into the nonprofit university, it was subtracted from the borough's tax ratables. In a gesture of fairness, the university established a somewhat informal "PILOT" (payment in lieu of taxes) program that contributed monies for the discretional use of the borough at large. At one point, even the idea of a swap was considered: the university would trade all of its Rutherford property for a large amount of the borough's Meadowlands property. However, the idea was not advanced. In the 1970s, plans were finalized for full-scale dormitories, and the eclectic Sammartino Hall (commonly known as the "Round Building") was completed. This concluded major building projects on the Rutherford campus and may have sealed its destiny to lose the status of headquarters for the university and, ultimately, its continued presence in the borough.

It would take twenty more years, and the tragic loss of its founders, before the university decided it might leave its beginnings behind. News spread quickly on a late March Monday in 1992. Around noon on Sunday the twenty-ninth, the Sammartinos' housekeeper found Sally and Peter dead on the second floor of their Rutherford home. Notes, asset lists and instructions were soon found directing police to contacts in case

Right: Sally and Peter Sammartino about 1990, founders of Fairleigh Dickinson University. *Courtesy of Fairleigh Dickinson University*.

Below: Peter Sammartino's signature. *Courtesy of Fairleigh Dickinson University*.

of death. It was apparent that Peter had shot Sally, his wife and partner of nearly sixty years, and then turned the gun on himself. A letter, dated March 28, read:

> We have lived far longer than most people. From now on it's mostly downhill. Soon I will be inactivated. Sally will succumb to the ravages of Alzheimer's Disease…It's about time we get out of the way and leave room for the young people…We have lived joyously for 58 years. Now because of the ravages of disease, we spend every hour of the day in a catatonic state. This doesn't make sense. —Peter Sammartino.

Their health had been declining as Sally suffered from an immune system deficiency and Alzheimer's was rapidly overtaking her once-sharp mind. Peter had a severe loss of hearing and struggled to speak. Within the previous six months, he had received a pacemaker and lost a kidney. His autopsy further revealed that he had a brain tumor. As per their last wishes, the Sammartinos were creamated, and a small private service was held on April 9, 1992. The Caledonian Pipe Band of Kearny was founded by Peter so it was fitting that the band would open a solemn occasion for its friend with the piping of "Amazing Grace." As the music echoed across the campus they had envisioned and between the buildings they had built, friends scattered a portion of Peter's and Sally's ashes on the Rutherford land in front of the castle, where their dream had begun sixty years ago.

Dwelling on their deaths seems lacking in fairness and respect considering how the couple lived their entire lives. Extensive travel and worldly opportunities beckoned, but both chose to remain most of their lives in Rutherford. Mrs. Sammartino was chairwoman of the State Commission on Women and president of the Garden State Ballet Foundation. She was active in the inception and advancement of Rutherford's William Carlos Williams Center and many other arts and education organizations statewide. In his autobiography, *Of Castles and Colleges*, Peter Sammartino dedicated the book "To my wife Sally, who has always done half the work but who has rarely gotten any of the credit."

Dr. Peter Sammartino founded numerous organizations, yet also found time to write thirty books. He was the president of the New York Cultural Center, in the former Gallery of Modern Art building at Columbus Circle. The Cultural Center was donated to the university by Huntington Hartford, heir to the A&P fortune. Mr. Sammartino was also the founder and chairman of the Restore Ellis Island Committee. The Peter Sammartino School of Education and the Peter Sammartino Scholarship Fund continue to honor the founders today.

An expected announcement that the Rutherford campus of Fairleigh Dickinson University was to close came in August 1993. The university began to shut down at the conclusion of the 1994 summer sessions. Unspecific plans were made for its sale. Many Rutherfordians pleaded with the borough to buy the property for educational use or protect it from unplanned misuse. But just as the twelve-acre site was falling into another cycle of sad abandonment, Lodi-based Felician College purchased the Rutherford campus in the fall of 1997. Almost immediately, plans were drawn up to preserve the castle and utilize the setting as it had been used as a college.

Another chapter of dreams was ready to unfold for the Borough of Rutherford.

EPILOGUE

A walk through Rutherford's history will almost always cross through Lincoln Park. This small, central resting place contains some of the most important testaments regarding the sacrifices made by Rutherford men and women in the defense of our freedom. Almost all of America's conflicts are represented in memorials erected by veterans' organizations and civic associations

It is staggering how many Rutherfordians have bravely devoted their lives to their county's call to service. Each name on every memorial deserves to have its complete story told. This book has concentrated on a somewhat local scope of history and is inadequate in length to recount these important tales. I am humbled by the record of honor represented in Lincoln Park.

I hope you will join me in discovering more of these stories in this park and throughout the Borough of Rutherford.

BIBLIOGRAPHY AND RESOURCES

Allan, Robert. *The Evolution of the Borough of Rutherford: Municipal Planning Project 5753-2.* Trenton, NJ: Work Projects Administration, 1939.

Barber, John, and Henry Howe. *Historical Collections of the State of New Jersey.* New York: S. Tuttle, 1844.

Becton, Dickinson and Company Archive. Franklin Lakes, NJ.

Bergen County Herald and News

Bergen County Historical Society. *Papers and Proceedings.* 15 vols. River Edge, NJ: 1902–22.

Bergen County Record

Brown, Lee Frances. *Then & Now Rutherford.* Charleston, SC: Arcadia Press, 2002.

Brydon, Norman F. *The Passaic River Past, Present, Future.* New Brunswick, NJ: Rutgers University Press, 1974.

Clayton, W. Woodford, and William Nelson. *History of Bergen and Passaic Counties.* Philadelphia: Everts & Peck, 1882.

Conklin, Agnes B., and Helen J. Swenson. *Old Houses of Rutherford, New Jersey.* Rutherford Committee of the New Jersey Tercentenary, 1964.

Davis, John David, ed. *Bergen County New Jersey Deed Records 1689–1801.* Baltimore: Heritage Books, 1995.

Ginman, R. *Introduction to the Meadows: The Developmental History*. Trenton: New Jersey Department of Community Affairs, 1968.

Gordon, Thomas F. *A Gazetteer of the State of New Jersey*. Trenton, NJ: n.p., 1834.

Hands, James. *A Brief History of Rutherford, New Jersey*. Rutherford Diamond Jubilee Historical Program, 1956.

Hay, Clyde, and William L. De Yoe. *New Barbadoes Neck in the Revolutionary War Days*. Rutherford Committee of the New Jersey Tercentenary and Fairleigh Dickinson University, 1964.

Heritage Studies, Inc. *The Operating Railroad Stations of New Jersey Historical Survey*. Prepared for New Jersey Transit, 1981.

Ketchum, Dr. J.J. *Rutherford, New Jersey An Ideal Suburb*. Rutherford: Rutherford News, 1892.

Lane, Wheaton. *From Indian Trail to Iron Horse: Travel and Transportation in New Jersey, 1620–1860*. Princeton, NJ: Princeton University Press, 1939.

Leiby, Adrian C. *Early Dutch and Swedish Settlers of New Jersey*. Princeton, NJ: D. Van Nostrand Co., 1964.

———. *The Hackensack Water Company, 1869–1969: A Centennial History*. River Edge, NJ: Bergen County Historical Society, 1969.

———. *The Revolutionary War in the Hackensack Valley*. New Brunswick, NJ: Rutgers University Press, 1962.

Leith, Rod, and John Moe. *Nomination of Lincoln Park for 2005 Bergen County Historic Preservation Commendation*. For the Rutherford Historic Preservation Commission, 2005.

Nelson, William, and Charles Shriner. *Paterson and its Environs*. New York: Lewis Historical Publishing Co., 1920.

Newark Star Ledger

Newark Sunday News

New Jersey Department of Transportation. *Master Plan for Transportation*. Trenton, 1972.

New York Times

Olsen, Kevin. *A Great Conveniency—A Maritime History of the Passaic River, Hackensack River, and Newark Bay*. Bergen County Historical Society, 1993.

Pleasants, Dr. Samuel. *Pre Revolutionary Roads in Northern New Jersey*. Rutherford Committee of the New Jersey Tercentenary and Fairleigh Dickinson University, 1964.

Potter, Janet Greenstein. *Great American Railroad Stations*. New York: John Wiley & Sons, Inc., 1996.

Riggs, Margaret G., ed. *Things Old and New from Rutherford*. New York: Bowne & Co., 1898.

Rutherford American

Rutherford Historic Preservation Commission, comp., with McCabe & Associates. *Historic Preservation 2006 Resurvey: A 25 Year Update of the 1981 Bergen County Historic Sites Survey*. 2006.

Rutherford National Bank. *Thirty Years: A Brief Outline History of Rutherford and its First Bank*. 1925.

Rutherford Republican

Sanborn Fire Insurance Maps for the Borough of Rutherford. Pelham, NY: Sanborn Company, various years.

South Bergenite

South Bergen News, News Leader

Stinson, Robert R. *Hudson County Today: Its History, People, Trades, Commerce, Institutions, and Industries*. Union, NJ: Hudson Dispatch, 1915.

Teal, J., and M. Teal. *Life and Death of the Salt Marsh*. Boston: Little, Brown & Co., 1969.

Van Valen, James M. *History of Bergen County*. New Jersey Publishing and Engraving Co., 1900.

Van Winkle, Daniel. *"Old Bergen" History and Reminiscences with Maps and Illustrations*. Jersey City, NJ: J.W. Harrison, 1902.

Van Winkle, James, ed. *A Genealogy of the Van Winkle Family 1630–1993,* Knoxville: Tennessee Valley Publishing, 1994.

Walker, A.H. *Atlas of Bergen County, New Jersey.* Reading, PA: C.C. Pease, 1876.

Westervelt, Frances A.J., ed. *History of Bergen County, New Jersey, 1630–1923.* New York: Lewis Historical Publishing Co., 1923.

Williams, William Carlos. *The Autobiography of William Carlos Williams.* New York: New Directions, 1967.

————. "Seventy Years Deep—Rutherford, NJ." *Holiday Magazine,* November 1954.

Winfield, C. *History of the County of Hudson, New Jersey.* New York: Kennard and Hay Publishing Co., 1874.

INDEX

S

ABOUT THE AUTHOR

William "Billy" Neumann will tell you first that he is a lifelong resident of Rutherford, New Jersey. He is the third generation to reside in a home that was once the main house of the large Beard family farm. For more than half the year, he sleeps outside on the home's open-air porch and tends to a garden that has continually yielded a harvest for over 135 years.

Neumann is a commercial photographer in New York City. Since 1985, he has produced award-winning images of business leaders, celebrities and politicians. He also has continuously documented the beauty of the Borough of Rutherford and its evolving history. These images have been used in numerous borough calendars, brochures, posters and more. He has produced guided tours of Rutherford, Paterson and New York City.

He is past chairman of Rutherford's Historic Preservation Commission and serves on other New Jersey historic committees, including Bergen County's Historic Preservation Advisory Board. He is a member of the Board of Directors of Paterson Habitat for Humanity and has pro bono affiliations with libraries, public radio and arts organizations.

Please visit us at
www.historypress.net